Images Online
Perspectives *on the* Museum Educational Site Licensing Project

The Museum Educational Site Licensing Project, Volume 2

EDITED BY
PATRICIA McCLUNG
CHRISTIE STEPHENSON

THE GETTY
INFORMATION
INSTITUTE

Printed in the United States of America

The Getty Information Institute
1200 Getty Center Drive, Suite 300
Los Angeles, California 90049-1680
310-440-7310
Fax: 310-440-7715
http://www.gii.getty.edu

Bridging art and technology, the Getty Information Institute provides leadership in networking cultural heritage information for research, education, and community enrichment. The Institute works internationally, nationally, and locally, and in concert with other Getty programs, to develop the model policies, tools, and methods needed to link cultural information globally.

Copyeditor: Linda Allen
Design: The Left Coast Group, Inc.
Production: Loraine Hoonhout, Robin Williams at The Left Coast Group, Inc.
Printing: Typecraft, Inc.

ISBN 0-89236-508-0

To all of the MESL project participants
in grateful acknowledgment
of the valuable contributions
their perspectives made to this project.

Patricia McClung
Christie Stephenson

⌣∴

Project Participants

Museums

Fowler Museum of
 Cultural History
George Eastman House
Harvard University Art Museums
Library of Congress
The Museum of Fine Arts, Houston
National Gallery of Art
National Museum of
 American Art

Universities

American University
Columbia University
Cornell University
University of Illinois at
 Urbana–Champaign
University of Maryland
University of Michigan
University of Virginia

Sponsoring Institutions

The Getty Information Institute (formerly the Getty
 Art History Information Program)
MUSE Educational Media

All Web sites referenced in this publication were active as of April 1998. If electronic documents referenced in this publication are no longer posted on a Web site, contact the Webmaster for the site and request an archive document, if available.

⸫

Contents

⸰ Foreword ix
ELEANOR FINK

⸰ Preface xi
KATHLEEN MCDONNELL

⸰ Introduction 1
PATRICIA MCCLUNG AND CHRISTIE STEPHENSON

⸰ Technology and the Teaching of African Art 3
BENJAMIN C. RAY

⸰ Digital Images in the Art History Classroom: Personal Reflections 13
SALLY M. PROMEY

⸰ A New Culture of Learning: Courses in Nineteenth-Century Art Using Digital Images 23
LAURA L. MEIXNER

⸰ Integrating Licensed Images into a Digital Library: Access and Resource Management Issues 29
DAVID MILLMAN

⸰ The Maryland Interactive System for Image Searching: Implementing a System to Facilitate Teaching with Digital Images 35
ELLEN YU BORKOWSKI AND CATHERINE HAYS

⸰ Evolutionary Progress: MESL's Impact at American University 47
KATHE HICKS ALBRECHT

⸰ Altering the Culture and Identity of the Museum: The Risks and Benefits of Providing Networked Information 57
ROGER BRUCE

⸰ Experiments at the Harvard Art Museums: MESL as a Catalyst for Change 63
MIRIAM STEWART

⸰ Musings on the Museum Educational Site Licensing Project 69
MELISSA SMITH LEVINE

⸰ About the Contributors 75

⸰ Credits 77

⌣⋅

Foreword

At this particular moment in history—as converging technologies bring images, sound, and text together for networked delivery—cultural institutions have a unique opportunity to shape their own destiny. The Getty Information Institute is dedicated to making information about our cultural heritage universally accessible. To this end, the Institute fosters demonstration projects that build on collaborative partnerships and capitalize on technological advances to strengthen the presence, quality, and accessibility of cultural information on emerging networks.

The Museum Educational Site Licensing Project (MESL) was undertaken in this vein, to explore the possibilities of electronic networks for increasing the availability of cultural heritage information. When it was launched in 1994, the MESL project had an ambitious agenda that resonated with the central vision of the Getty Information Institute. Its primary focus was to define acceptable terms and conditions for distributing museum images for educational purposes. Framed as a practical demonstration project involving 14 institutions, it necessarily encompassed much more. Before the project ended in the summer of 1997, participants grappled with a variety of issues from content selection, image capture, and standards for recording and transmitting data to systems interface design, faculty and student training in new technology, software tool development, use and impact studies, economic analyses, and intellectual property questions.

This report and its companion volume, *Delivering Digital Images: Cultural Heritage Resources for Education,* document as fully as possible the project's methodology, its central issues, and its lessons, including issues that were unresolved and need to evolve over time by trial and error in an iterative process.

The project's success was owed to a collaborative meeting of some of the best minds from among the universities and museums that participated. The project is indebted to the institutions that met the challenges it presented, and to the people in those institutions who made it happen, brought the critical issues to the surface, and wrote about them for this publication. Collaborations such as theirs require steadfast commitment, a daunting amount of hard work, and the determination to achieve consensus on crucial issues. Their efforts, documented here, demonstrate new ways to harness technology to make the world's cultural heritage more accessible. More importantly, they foreshadow many of the transformational benefits that in time both teachers and students will enjoy.

ELEANOR FINK
DIRECTOR
THE GETTY INFORMATION INSTITUTE

Preface

The Museum Educational Site Licensing Project (MESL) was launched in 1994 as part of the Getty Information Institute's Imaging Initiative, which was created to act as a catalyst in improving networked access to cultural heritage materials. MESL was conceived as a collaborative project rather than a research assignment, on the assumption that a real-world experiment—ambitious and bold though it was—was the best way to surface and engage the primary issues. More importantly, we believed that the challenges impeding progress, particularly the legal, administrative, and technical ones, lent themselves to collaborative experimentation and problem solving.

As it turned out, the MESL project far exceeded our expectations, thanks to the creative energy that evolved among the participants over the course of the project. The MESL publication *Delivering Digital Images: Cultural Heritage Resources for Education* covers the project's methodologies and essential findings. This companion volume, *Images Online: Perspectives on the Museum Educational Site Licensing Project,* captures some of the individual voices of the MESL participants, and reflects the extraordinary talent and personal commitment to this experiment that became the hallmark of the MESL project.

I want to extend a special thanks to Christie Stephenson, MESL Project Director, and Patti McClung, MESL Project Manager. Through their hard work, personal dedication, and relentless professionalism, Christie and Patti were largely responsible for MESL's success. Their thoughtful guidance as well as their unwavering respect for the people and participating institutions nurtured the endeavor's progress and preserved the spirit of the collaboration.

<div align="right">

KATHLEEN McDONNELL
ASSOCIATE DIRECTOR
THE GETTY INFORMATION INSTITUTE

</div>

⌣∴

Introduction

The Museum Educational Site Licensing Project (MESL) offered a framework for seven collecting institutions, primarily museums, and seven universities to experiment with new ways to distribute visual information—both images and related textual materials. It was a complex project with an ambitious agenda. The MESL participants investigated legal and administrative issues, technical infrastructure requirements and access questions, processes for selecting database content, ways in which the materials were used, and the impact, as well as economic considerations, of making digital images available. *Delivering Digital Images: Cultural Heritage Resources for Education* is organized around these topics and represents the official record of the project's findings.

This volume, *Images Online: Perspectives on the Museum Educational Site Licensing Project,* is published simultaneously with the former in order to capture some of the "unofficial" insights that the MESL project stimulated. In the course of the project's three-year history, from its inception in the spring of 1994 to its conclusion in the summer of 1997, hundreds of people were directly involved in its implementation and thousands participated, whether they knew it or not, as users of the MESL data. The MESL project touched institutions and individuals on many different levels. It served as a catalyst for all kinds of experimentation—and in turn, further speculation—on how to capitalize on available technology to improve access to cultural heritage information. The essays contained in this volume capture some of those perspectives on various aspects of the MESL project's process and its outcome.

This volume does not follow a chronological order, but begins instead with three essays by faculty members who used MESL images extensively in academic courses. Although the infrastructure and implementation parts of the MESL project consumed much of the attention, the most important benefits of the project relate to its impact on teaching and learning. Eventually, once the images were selected, captured in digital form, described, distributed, and loaded at the seven university sites, the project's focus shifted—from what went on behind the technical curtain to classroom and student use of the materials. To be sure that these perspectives are not lost in the morass of detail, we highlight them at the outset.

Describing a course at the University of Virginia, Benjamin Ray leads off. His essay covers use of MESL images from the Fowler Museum to help students explore the question of what African art can tell us about the society that produced it. Sally Promey reports on the innovative ways in which she experimented with MESL images in several courses, and the tools that were developed at the University of Maryland to support her. Laura Meixner discusses using the MESL images at Cornell University in a course designed to increase students' awareness of visual culture, demonstrating the relevance of art to everyday life. All three essays point to changes in the classroom dynamic and ways in which the MESL project inspired students to take more responsibility for their own learning. In some instances, students became teachers themselves as a result of their interaction with the images and related textual information.

The next section of *Images Online* goes behind the curtain and looks at the technical infrastructure and the tools developed to facilitate access for faculty, students, and lifelong learners. David Millman, from Columbia University, analyzes the challenges posed by MESL-like content in designing an architecture for the digital library. He also speculates about ways in which the MESL model can be adapted and extended, proposing a new

metadata model to provide coherent access to the expanding universe of digital content. Catherine Hays and Ellen Borkowski share their experiences in building software tools at the University of Maryland, specifically tailored to support the use of MESL images in the classroom. They explain how an iterative and collaborative process among faculty, academic computing staff, and MESL team members contributed not only to successful development of "intuitive" tools, but also to expanded pedagogical goals.

Following the "whys" and "hows" of the MESL project is a section that speaks to the ways in which participating institutions were affected. Kathe Albrecht uses the MESL project as a window on the evolutionary nature of changes under way that affect institutional infrastructures, faculty and student training programs, teaching styles, system interoperability standards, and intellectual property rights. Roger Bruce offers his observations of the MESL project's impact on the George Eastman House, including its culture and self-concept. He also speculates about how the availability of electronic resources is likely to affect museum services and organizational structure in the future. Miriam Stewart offers her insights into the ways in which the Harvard University Art Museums have responded to the challenge of serving as digital content providers. She shares some of the practical procedural considerations involved in scanning and image documentation, as well as how the Harvard University Art Museums have been able to extend access to collections through MESL and other similar projects.

The last article is "Musings on the Museum Educational Site Licensing Project." Melissa Smith Levine takes on the critically important legal issues that underlay the project from its inception, and focuses on the purpose of the site licensing model. She suggests that the business and financial issues may be clouding our vision prematurely, and encourages an emphasis on the product and its distribution, allowing the administrative models to evolve in due course.

All of the MESL project participants provided insights and beneficial perspectives in various ways throughout the project's life. These essays, while not definitive, shed light on some of the practical and philosophical issues that need to be engaged as cultural institutions experiment with providing digital information to their clientele.

PATRICIA MCCLUNG
MESL PROJECT MANAGER

CHRISTIE STEPHENSON
MESL PROJECT DIRECTOR

⋰

Technology and the Teaching of African Art

BENJAMIN C. RAY

In the next century, technologically equipped classrooms and large collections of digital images will be readily available, providing enormous opportunities for innovative teaching—opportunities which some teachers are just now beginning to discover. The educational value of computer technology in the humanities lies in both the informational resources of the Internet and the creative potential of the World Wide Web. The Web's ability to display both texts and images not only fosters student-oriented teaching and collaborative learning in the classroom, but also enables students themselves to produce new informational resources for the Web, especially in projects that use images.

In 1996, I created a course at the University of Virginia titled "African Art and the Virtual Museum," which was jointly offered by the Department of Religious Studies and the Art Department. The following description explains its aims and purposes:

> "African Art and the Virtual Museum" enables students to learn about African art and to demonstrate what they have learned by creating original Web-based exhibitions of African art. Two class meetings a week will be devoted to illustrated lectures and student presentations; a third will involve computer instruction; an additional one-hour lab session may be added for an optional credit hour. There will be two museum visits that will include lectures by curators at the National Museum of African Art and the Virginia Museum of Fine Arts.

The course used the digitized images from the Fowler Museum of Cultural History of the University of California at Los Angeles, provided through the Museum Educational Site Licensing Project (MESL), as well as images from the African art collections of the Bayly Museum of the University of Virginia and the Hampton University Museum of Hampton University, Hampton, Virginia. Following a set of exhibition guidelines, students drew upon lectures, assigned readings, museum visits, and conventional library research to create their own Web-based exhibitions. Students selected images related to a theme of their choice and wrote the texts that introduced the exhibit and accompanied each image. The special challenge of the course was to enable students to bring what they had learned in the classroom to a wider audience, to "transform students into teachers," as one student put it.

Over the years, I have learned a great deal about African art in the process of exhibiting it, and I wondered how it might be possible to bring the same educational process into the classroom. Creating an exhibition of African art entails detailed library research, the writing of short and informative label texts, and the creative combining of objects around a general cultural theme. Such an exercise would enable students to deal with African art objects firsthand and to apply what they had learned about African religions and cultures in a practical fashion. It would also enable them to wrestle with the important issue of "representing" African cultures in a Western technological medium. As for the exhibitions themselves, the students would not just be discussing the issues of representation, but would be doing it. Wellesley College has already had success with an art history class in which students created an exhibition of African art in the Jewett Museum. Unfortunately, at the University of Virginia the distance between the Bayly Museum and the museum's off-site collections' storage facility made such a project unfeasible.

Why not, then, try to use imaging technology instead? Making a virtue of necessity, the use of digital images would enable each student to be his/her own curator and allow access to a large and superlative collection of "objects" to study and exhibit. Although the students would not be producing exhibitions in an actual museum, the curatorial and scholarly tasks required to produce an electronic exhibition are nearly the same, with the added advantage of allowing students to learn computer imaging skills. Aiming the Web exhibitions at a general audience beyond the classroom would have an educational advantage: requiring students to think self-consciously about the scholarly goals of their work. The whole process would raise the level of student participation in the scholarship of the subject far beyond the usual methods of course examinations and/or term papers written only for the instructor.

The idea of the course took shape, and in the spring of 1996 twenty-one students and I set out to see whether it would work. At this point I possessed nothing more than the basic word processing and e-mail skills; nor, it turned out, did any of the students. Weekly training sessions in HTML, image processing, and Web page construction in a computer lab were, therefore, essential. Instructional resources and technological arrangements were provided by the University of Virginia's Teaching and Technology in the Classroom Initiative, a program that also includes some release time for instructors to prepare for technologically innovative classroom projects. During the semester before offering the course, I acquired a basic introduction to the necessary computer and HTML skills, but needed reinforcement during the semester in the computer classroom with the students.

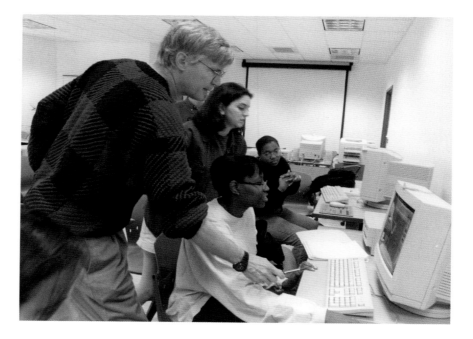

▶ **FIGURE 1** Benjamin Ray and students enrolled in "African Art and the Virtual Museum" working together in the computer lab at the University of Virginia

My participation in these labs as a learner alongside the students helped build student confidence in their ability to tackle the sometimes challenging technological features of the course. I was also able to appreciate the difficulties students encountered in learning these

procedures, which helped me to advise the computer instructor on his teaching methods and the sequencing of skills to be taught. An important lesson we learned immediately was that students need written step-by-step instructions for reference after they leave the computer training session. For most students, executing the computer procedures correctly once or twice in the classroom does not mean they have been learned well enough to be repeated several days later. Written instructions were attached to the course home page after each computer session. (Today's online Web editing software programs are simplifying basic HTML procedures to more manageable proportions.)

One of the best ways students can learn about another culture is to study the images produced by its artists, because in portraying the world through images, artists express a great deal about themselves and the societies in which they live. Images give students direct visual contact with those societies. With concrete visual images before them, students form impressions and gain insights immediately and are able to reflect on cultural differences and similarities.

For these reasons, it is difficult to overestimate the educational power of the study of images, especially in today's image-rich world. When linked to standard print publications, such as African art exhibition catalogs, and current scholarly discussions about representing Africa in Western museums, the classroom study of African art becomes a fascinating and illuminating subject for teachers and students alike.

Nevertheless, because of the long-standing prejudice against images in the academic environment, with the sole exception of departments of art history, the case must be made for the educational value of images in the humanities. Barbara Stafford's book *Good Looking: Essays on the Virtue of Images*[1] does so in the strongest terms. She argues that "imaging, ranging from high art to popular illusions, remains the richest, most fascinating modality for configuring and conveying ideas." She challenges the supposed primacy of language and the printed word with the claim that the study of images reveals not only the surfaces of things but also the reflexivity of cultures as they represent and portray themselves in normative ways. This occurs, for example, in Sande society masquerades, whose Sowei masks exemplify the moral and aesthetic norms of female beauty, and in certain Egungun masquerades, whose masks and dances ridicule socially unacceptable behavior. The fact that images invite serious, often critical thought, not just emotional responses, leads to a deeper understanding of the society that made them. Hence, Stafford calls on "established and aspiring imagists across disciplinary boundaries to confront the fundamental task of remaking the image of images." Stafford argues that in noticing differences between cultures through their images, we begin to notice certain likenesses and to make deeper connections, thus transforming our understanding and sometimes ourselves in the process. Through studying images of "others," Stafford argues, we begin to "fit our local perspectives into a bigger picture of humanity."

With Stafford's views in mind, together with Ivan Karp and Steven D. Lavine's book *Exhibiting Cultures: The Poetics and Politics of Museum Display*,[2] I focused the course on a number of preliminary questions. How much can an African art object "tell" us about the society from which it comes? How have museum exhibitions and African art scholars tried to use images to understand cultural otherness? How have museum exhibitions of African art changed and developed over the years? What are the stereotypes to be avoided? How can visitors to museums, real or virtual, make "connections" with the objects in the exhibit?

For the first few weeks, each class began with a brief student presentation of two objects from the two textbook museum catalogs. This gave students some practice in "presenting" African art to their peers, which helped to facilitate discussion and reflection on the strengths and weaknesses of the catalogs' format, style, and label content. Students brought the catalogs to class, had them open on their desks, and were able to speak to specific issues, guided by another student's presentation. Informed by scholarly essays on the

history of African art studies and on museum representations of African culture in Karp and Lavine's *Exhibiting Cultures,* the student critiques became more sophisticated as the students became more adept at sorting out effective label texts. Gradually, using this method the class and I were able to develop a consensus about the most useful components of a written label. This process led to the following guidelines:

> Since objects of traditional African art are generally made for use in specific contexts, which are often ceremonial and religious, the museum label describing the object should inform the viewer both about the object and its context of use. This is done by referring to certain prominent features of the object, its particular shape, formal properties, and artistic detail, and by explaining these features in terms of contextual social, moral, and religious ideas and actions. This helps the viewer to "see" the object within its own cultural setting. The label thus educates the viewer's eye by showing how the object expresses important African moral and religious ideas and actions. If possible, the label should quote a relevant statement (proverb, poetic verse, myth text) taken from the society itself or an informant's words concerning the object or context. The label must do this with a minimum of words for an audience that possesses little or no knowledge of African art. The label, of course, represents the exhibit curator's own knowledge and personal point of view. The label is necessarily interpretive and it should give the viewer opportunity to think about the object and make some connections to it and African culture.

After some practice in evaluating catalog labels with the above guidelines in mind, the students became adept at applying these principles to their own work. Limiting the initial student presentations to about ten minutes of the class period allowed time to begin a survey of African art objects via conventional slide-projected images and lecture format. Here, I was both guided by and limited to the digitized image collections to which the University of Virginia has copyright access. At the present time, the "fair use" clause of the copyright law is interpreted in such a way that a limited number of digitized images may be taken from a published source for instructional use if access is restricted by a password, valid only for the students in the course. (As the fair use guidelines are in the process of change, teachers should check their institution's policy on this matter.)

Since the images to which I had access were those the students would use in their exhibitions, my first task was to teach them as much as possible about the main features of the objects and their contexts of use. The Fowler Museum's collection is especially strong in the areas of Yoruba and Asante cultures, while the Hampton University Museum and Bayly Museum collections focus mainly on the Kuba and include typical objects from a variety of West African societies. Fortunately, the Yoruba, Asante, and Kuba cultures are also among the best represented in scholarly research, so the students could become engaged in the scholarship of these objects in significant detail using conventional library resources.

The focusing framework in the lectures and student presentations was twofold: (1) the aesthetic and symbolic characteristics of the object and (2) the social and ritual context of the object. I began by presenting a general overview of the various types of African art (masks, headdresses, figure sculptures, ancestor figures, royal emblems, animal figures, textiles, metalwork, clay sculpture, pottery) and ceremonial contexts (initiation, seasonal ceremonies, funerals, public festivals, altars, and shrines), using images from a wide range of West and Central African societies. Then we turned to some of the readings on exhibiting African art in order to introduce that topic. For the next four weeks, we concentrated on the art of Asante, Yoruba, and Kuba, given the strengths of our database of images of objects from these societies. This was followed by three lectures on masks and two on images of ancestors, interspersed with student critiques of catalog presentations of these subjects. By

this time there was enough background for the museum visits and talks with curators at the National Museum of African Art, the Virginia Museum of Fine Arts, and the Bayly Museum, a week before mid-semester exhibitions were due. From mid-semester onward, we delved deeper into questions of exhibiting and describing African art, as well as certain cultural institutions, such as the ritual and symbolism of kingship and the use of art objects in divination and healing rituals. Occasionally, we spent a whole class on a single object to see how far current scholarship and our own thinking could take us toward understanding the object and its context. Finally, we took a brief look at the work of two well-known Yoruba artists, Olowe of Ise, who died in 1938, and contemporary carver Lamidi Fakaye of Ibadan and Ile-Ife.

Because the students had to present a small electronic exhibition by mid-semester, they needed to begin thinking about the choice of an exhibition theme soon after the semester started. (See Exhibition Guidelines on pages 10–11.) The two textbooks for the course, Roy Sieber and Roslyn Adele Walker's *African Art in the Cycle of Life*[3] and Richard B. Woodward's *African Art in the Virginia Museum of Fine Arts*,[4] are broad in scope and served as excellent introductions to a range of thematic subjects and contrasting presentation styles. The students, of course, chose their exhibition themes on the basis of their own interests and on what seemed to them visually interesting and culturally important. Consultations with me helped clarify their ideas and identify the relevant source material placed on the reserve reading shelves in the library.

The process of choosing an exhibition theme, defining its general nature and scope, and selecting the objects to portray it led to the recognition that every exhibition of African art is a curator's "choice," and hence that every exhibition displays the curator's own perceptions and priorities in understanding African cultures. Students created written explanations of their themes which served as introductions to the exhibitions. They also put their names to their exhibitions, as some museum curators are now beginning to do. Here, for example, is the introductory text for an exhibition titled "Metalworks from the 'Gold Coast' Area," by Stephanie Sareeram (see Figure 2 on page 8).

> Along the Atlantic coast of Africa, where the modern countries of Benin, Ghana, and Nigeria are situated, shines a region of earthly wealth, sacred imagination, kingly riches, and opulent splendor. The famed *Gold Coast* of Africa is the home of some of the finest goldsmiths and ironworkers the world has ever known. For centuries, artisans have crafted works out of the region's indigenous metals for kings, priests, families, gods, ancestors, and spirits. Each piece is adorned carefully and imbued with the essence of things beyond mere mortals.
>
> The electronic exhibition displays ten works representing the societies of the Asante, the Fon, the Yoruba, and the Edo kingdom of Benin. Each has a unique significance to the multi-leveled relationships within these groups—from the king to his people, from the spirits to the judiciary, and from the living to the dead.

One of the more difficult tasks for students was to include their own perceptions in the exhibition. They found it difficult to avoid speaking with the impersonal voice of the museum curator and thus to "connect" themselves to the viewer and the objects. One of the reasons for adopting the impersonal voice was the students' desire for scholarly accuracy. They felt a professional sense of scholarly responsibility for their exhibitions, realizing that other students around the university (and potentially around the world) could access their work; they wanted it to meet the highest scholarly standards, without introducing their own subjectivity. Given their contact with museum curators and engagement with the most recently published research, they considered themselves active participants in the current world of African art scholarship and curatorship. The Web had "transformed them

List of Student Exhibitions

Roles of Women as Depicted in African Art

Art of Crisis: An Exploration of African Art

The Many Faces of Africa

Aesthetics of Female Images in African Art

African Musical Instruments: Representing Art and Life

Metalworks from the "Gold Coast" Area

Crossing Over: Masks and Initiation Rites and Secret Societies

Fetish/Power/Art: Changing Perspectives on African Art

The Power of African Art

Continuity through the Ages: The Relationship with the Spiritual World as Depicted in African Art

Keeping the Dead Alive: Ancestor Images in African Art

Images of Royalty and Power in African Art

Initiates and Elders: Transformation and Power in African Art

Masks in the Cycle of African Life

Images of Animals in African Art

The Reality of the African Mask

Women in African Art: Family, Life, and Afterlife

Creations from the African Metalsmiths

Images of African Women in the Cycle of Life

Animal Imagery in African Art

Communication with the Spirit World through African Art

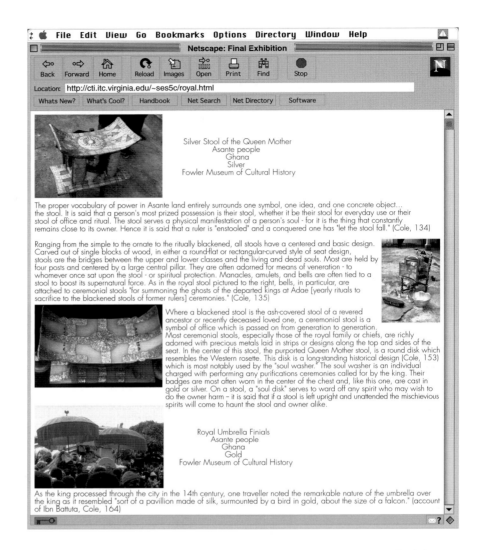

▶ **FIGURE 2** A sample entry about Asante stools from Stephanie Sareeram's Web exhibition, "Metalworks from the 'Gold Coast' Area"

into teachers" who cherished the value of interesting and reliable scholarship. To me, this was one of the unexpected and stunning results of the students' academic involvement with the educational features of the Web.

Having engaged in a scholarly research project and created their own materials for the Web, the students were, of course, fully aware of the difference between this use of the Web and simply downloading information from it. Indeed, they were in an excellent position to evaluate other materials on African art on the Internet, as they had done with the scholarly museum catalogs in class. One of their exercises was to critique anonymously each other's midterm exhibitions for design, organization, and content, as well as other exhibitions on the Web. The students proved to be remarkably successful in doing this and helpful to each other in their criticisms and suggestions for improvement. The students also learned firsthand that the information on the Web is only as good as the sources from which it was constructed, no matter how fancy the Web pages may appear on the screen.

Even though the students recognized that their scholarly products were produced for this course, they were prepared to have them evaluated by other faculty members teaching African studies subjects in other departments, something that is easy and convenient to do via the online environment. This is also a simple device for engendering faculty collegiality and interdisciplinary teaching.

The course was fundamentally project-oriented, and almost everything taught was relevant to a particular task. Whether it was a specific computer skill, a guideline to writing object labels, or the best scholarly studies to consult, everything in the course served as a resource. I found this to be a refreshing and effective mode of teaching. I was no longer teaching for the sake of test-taking or paper-writing but for the sake of project effectiveness and collaborative learning, so students could both grasp the material and use it. Students themselves brought resources to the class—observations about interesting museum exhibitions they had seen, Africa-related Web sites they had discovered, and so on.

In addition to published material and my lectures, the resources for the course included the student exhibitions themselves, for each student could examine other students' projects at any time during the semester. I deliberately set up the course with a roster listing each student's project on the course home page, so students would have the opportunity to consult each other's work. I, too, engaged in frequent monitoring of their projects and gave suggestions via the class e-mail account, which all could read.

Given the potential for violation of the University of Virginia's student-run honor code, the class addressed the issue of plagiarism at the outset. Students liked the possibility of accessing each other's work, and they decided that borrowing each other's Web design techniques was both permissible and helpful toward the attainment of their goals. They drew the line, of course, at the borrowing of each other's exhibition themes and label content. During the lab sessions, students frequently assisted each other in image processing and Web construction techniques. In this way, the least experienced students caught up with the more experienced students and gained confidence with the computer. Looking at each other's work also stimulated their efforts and raised the level of their academic expectations.

Another concern was aestheticizing the objects on the Web page. Some students removed background material from around the objects in the photographs, making the images into what are called "transparencies." They then placed the objects against Web page backgrounds of various colors and patterns so that the objects appeared to float in space, almost three-dimensionally in front of the background design. Students found this effect artistically attractive but worried about the possible misinterpretations that might arise by taking the objects out of their "own" space, as it were, even if this space were only the color background and lighting effects of a studio-produced photograph. Consequently, students wished to include interpretive field photographs of objects in their contexts of use, such as masks shown being worn by dancers, whenever they could find them. Using these images via links within the object labels allowed the students to acquaint the viewer with images of an object's actual life setting. This technique also gave students the opportunity to write additional material about cultural context.

One student, Daniel Haithcock, addressed these issues in "A Note From the Curator" in the exhibition titled "Crossing Over: Masks and Initiation Rites and Secret Societies."

> This Web project has been designed with the goal of educating visitors about the cultures and ideals involved in African art. . . . In order to appreciate African art fully, one must discover the original purpose of the object and explore the culture that created it. Although the total experience of an object can never be replicated once it has been removed from its original context, supplementary information is crucial for its appreciation. To this end, several additions have been

made to the traditional museum approach to exhibiting African art. I have attempted to use longer, more educational labels that describe more about the cultural context of the object and less about the aesthetic qualities. When available, I have included photographs showing how the masks were meant to be displayed by their creators. My desire is that as you view the beautiful masks exhibited here, you will also acquire a greater appreciation of the culture that created the masks and the manner in which they are used. I realize that by changing background colors and through my treatment of the images, I have also added yet another foreign context to an object already robbed of its true existence. My only hope is that the context I create enhances your desire to learn more about the mask and the culture that created it.

Exhibition Guidelines

Midterm exhibitions should consist of six images with descriptive labels. The images may be left-justified or placed in any position on the Web page in relation to the label. The images should be imported in both the small GIF format and the larger JPEG format, so that the viewer can study the object in greater detail. The exhibition should open with a title, followed by an opening statement, two or three paragraphs in length, that explains the exhibition's theme. A key image might follow immediately below the exhibition title (or stand next to it) as a way of visually conveying the theme of the exhibition. The six images should be taken from at least four different societies. A map locating the societies represented in the exhibition is not necessary for the midterm.

The final exhibitions should be expanded and revised versions of the midterm exhibitions, made slightly more complex, with more descriptive information, and about double in size—twelve images in all.

1. *Exhibition Theme:* Consider whether your exhibition theme should be slightly revised to include six more objects. You may also choose to reduce (or expand) the number of societies represented in your exhibition. (The final exhibition should present images from at least two different societies.) Your final exhibition should engage in drawing some comparisons between the objects and their social, moral, and religious contexts, as well as some pertinent comparisons with aspects of Western culture and human life in general. Here is where your exhibition can express a distinctive point of view, in addition to conveying artistic and cultural information. Re-read Warren H. Robin's article "Making the Galleries Sing: Displaying African Art" (*Museum News* 1994, vol. 73, no. 5: 36–41) as well as the articles by Susan Vogel and Ivan Karp in *Exhibiting Cultures*.

2. *Design, Structure, and Organization:* The exhibition should have a separate title page that contains the title (with perhaps a subtitle), your name, and an image that conveys the general theme of the exhibition. If there is enough space, you should also write a brief statement to introduce the exhibition theme. The statement should be short enough so that it appears on the title page, without the need to scroll too much down the page. At the bottom of the title page there should be three or four links to the various parts (pages) of your exhibition, each part having its own title. These same links should appear at the end of each section of the exhibition so the viewer can navigate from one section to another and return to the title page. As a general rule you should place your labels next to the images so that the viewer can see the image and the label together. Each thumbnail image (GIF) should be linked to a

(continued on following page)

It is necessary, of course, to ask how well this class in African art "taught" Africa. In view of the fact that approximately one-third of the students' time was taken up with learning and applying the technology of image processing and Web page construction (a task that is fortunately becoming simpler due to new Web page editing software), a certain amount of course content had to be compromised. Extensive reading in African religions and culture was sacrificed, as was a broader range of art objects, for the sake of completing the exhibitions on time. Students also became acquainted with the odd fact that some of the most popular art objects in Western collections, such as the Punu Okuyi mask, have received little attention in the literature, while others, such as the Mende Sowei mask, have received volumes. Consultation with me helped avoid the use of too many of the less well researched objects. Given the project-driven nature of the course, students also tended to

Exhibition Guidelines (continued)

larger, more detailed version of the image (JPEG). This can be done by "wrapping" the JPEG image anchor around the GIF image or by "mapping" the GIF image so that it links to the JPEG image. If you would like to make your images into transparencies and place them against a particular background, such as an African fabric, this will enhance the aesthetics of your exhibition. However, such artistic features are time-consuming tasks and should not be undertaken at the expense of the research and writing components of your exhibition. Your exhibition should contain a map of Africa that shows the locations of the societies whose objects are represented in your exhibition. The best method is to use the scanned images of maps provided in your image collections, and then type the names of the societies in the appropriate locations on the digitized map.

3. *Textual Content:* Make the labels complex, by adding links based on your additional library research. Each part of the exhibition should begin with a brief statement to explain how it fits into the overall theme. You might also give a brief descriptive title to the object in your image to attract the viewer's attention. Each label should begin with the name of the object, the society or culture from which it comes, and the nation or state to which it belongs. You should also include an image source or museum credit line, for example, "Hampton University Museum." The labels should contain links to bibliographical references, either at the end of the label or within the body of the text. There should also be links to "further information" pages concerning some major point (or points) that appear in the label. Be sure there are links at the ends of these pages that return the reader to the label. You might find it useful in some cases to crop the JPEG image and enlarge one or more parts of it so the viewer can focus on a specific feature or features. You should create a link within the text label to this part of the image and add a few more lines of text describing this feature, and then create a link that returns to the original label.

4. *Context Photographs:* Since there are very few context photos in the Fowler Museum images, it will be necessary to scan them from published sources. I have already provided some scanned images in your digitized image collection source, "images shown in class." One of the most extensive sources is Michael Huet's *The Art, Ritual and Drama of Africa* (New York: Pantheon 1978). Most of the recent books on African art also contain excellent field photos showing the objects in context. The journal *African Arts* is full of field photographs; consult the complete index to *African Arts* in your course packet. Providing too many context photos is a time-consuming process and should be low on your list of priorities.

restrict their attention to what they needed to know about the twelve objects in their exhibitions, neglecting a deeper and more comprehensive understanding of African art and culture.

Nevertheless, the exhibitions achieved considerable depth and focus. The insertion of links within the object labels gave students the opportunity to add more Web pages without infringing on the exhibition format; thus, they were able to include the results of more extensive research as the semester progressed. This technique greatly enriched the exhibitions and enabled the better students to write short essays on each of their twelve objects. Fortunately, most students reached the peak of the computer learning curve by mid-semester, so they could devote more time to the selection of objects and their library research. Some would have preferred to have done all the research first, allowing greater depth at the outset, and then to have turned to learning the computer skills. They felt distracted by trying to do the library research and learn computer skills at the same time. This was a valid criticism, and the course will be changed accordingly.

To conclude, I would emphasize that technology is best used in the classroom as interactively, creatively, and collaboratively as possible. On this pedagogical point, I can quote with approval a statement by Terry Crane, an Apple vice president: "Instead of isolating students, technology actually encouraged them to collaborate more than in traditional classrooms. Students also learned to explore and represent information dynamically and creatively, communicate effectively about complex processes and become more socially confident." While classroom use of the Internet as an information resource is becoming increasingly valuable, even more valuable is the opportunity for students to become active participants in the Internet's resources by designing and creating original educational material, whether for local use within the classroom, the school as a whole, or the Web-viewing public around the world. By making use of this technology, teachers of African Studies will gain some significant educational results both in the classroom and beyond, even though a considerable amount of preparation is involved, especially at the level attempted in this course. In addition, it is safe to say that I would never have ventured down this path, nor seen the great possibilities for the use of images in the classroom, had it not been for the availability of the Fowler Museum's superlative images through the MESL project and the work of the Virginia project team.

► Notes

This article is a shorter version of one which will appear in a forthcoming anthology, *Teaching Africa*, ed. Misty Bastian and Jane Parpart.

1. Barbara Stafford, *Good Looking: Essays on the Virtue of Images* (MIT Press, 1996): 4.

2. Ivan Karp and Steven D. Lavine, *Exhibiting Cultures: The Poetics and Politics of Museum Display* (Smithsonian Institution Press, 1991).

3. Roy Sieber and Roslyn Adele Walker, *African Art in the Cycle of Life* (Smithsonian Institution, 1987).

4. Richard B. Woodward, *African Art in the Virginia Museum of Fine Arts* (Virginia Museum of Fine Arts, 1994).

⁖

Digital Images in the Art History Classroom : Personal Reflections

SALLY M. PROMEY

▶ Introduction and Context

Images occupy a central position in the art history curriculum. Unlike most professionals in other disciplines, art historians cannot conduct class without images that can be seen clearly by all present. This makes high-quality image delivery a critical feature of classroom instruction. As new technologies alter the expectations and the mechanisms of visual display, art historians are among the first who must come to terms with these changes. The Museum Educational Site Licensing Project (MESL) has allowed members of the faculty at the University of Maryland to rethink the use of conventional materials and create fresh ways of presenting content. Transforming the curriculum as we move toward digital imaging systems as a principal mechanism for classroom image delivery is both difficult and time-consuming. It involves a wide range of activities and concerns. At the University of Maryland, we are especially fortunate to have active campus-wide support for the MESL project and related endeavors, as well as many colleagues who are committed to exploring and enhancing new media for teaching and research.

For teachers and students in our institution, the MESL project has afforded an unprecedented opportunity to use high-quality digitized images, direct from the collections to which the originals belong, with almost no limitations except that use be educational and that it take place on a restricted campus network.[1] While the scope of implementations has been broad—from advanced graduate seminars in the AT&T Teaching Theater to flexible interactive modules for use inside and outside class with small and large introductory-level undergraduate courses—the goal of this article is modest. I do not intend my remarks to be comprehensive, but only to present a set of personal reflections on the experience of teaching two courses enriched by MESL materials at the University of Maryland.

When, in the fall of 1994, my department chair encouraged me to write a proposal for institutional participation in the MESL project, and then (when our proposal was successful) to serve as University of Maryland's coordinator for the project, I had significant reservations about accepting this responsibility. I had several concerns about new electronic technologies, ranging from very practical pedagogical and professional matters, like image quality and selection, to social and political issues, like equality of access across economic and demographic barriers. Most important, however, I considered myself a novice in the electronic arena. I had in the past tended to approach computers principally as word processors, as useful tools of research and publication, and not because they had any intrinsic fascination for me. With very little prior experience in instructional technology, I knew it would take an enormous investment of time and energy to acquire the necessary level of technical skill and expertise. I frankly feared a classroom situation that might publicly display my own ignorance. As I considered what I might do with digital images in the classroom, the obstacles seemed enormous. At first it was difficult even to articulate specific expectations with respect to possible applications. What *could* this technology offer me and my students that other media did not already provide?

I was determined, from the beginning, to conceive of digital images not simply as a "replacement" technology for slides. However, in order to think around and beyond this model, I needed to allow myself a familiar base, in this case a mechanism for searching, retrieving, and sorting MESL images (and their accompanying textual documents) in a manner that in its initial version, I had to concede, was like arranging slides on a light table. Academic Information Technology Services (aITs) on our campus was already at work creating ISIS™ (Interactive System for Image Searching) to provide both this functionality and a projection mode. The *process* by which the ISIS software was developed was perhaps even more important to the success of the MESL project at the University of Maryland than the actual product itself (though the product is certainly significant). From this process we learned, early in the project, the value of close collaboration among people with expertise in different fields. With Ellen Borkowski (Coordinator of Instructional Technology and Support, Teaching Technologies, aITs) facilitating our labor, faculty, technologists, instructional designers, librarians, and slide curators worked together to produce this multi-task tool. Because the development of ISIS took place on our own campus and because it grew out of a widely shared goal of making MESL materials useful in the classroom, the process has been open-ended. In response to feedback and in-class testing, we continue to refine ISIS for future uses beyond the MESL project itself.

The open-endedness and the collaborative experience of assembling this tool exemplify the development of teaching technologies at the University of Maryland. In the case of ISIS, we did not have to settle over the long term for a product based on my early and tentative notions of what I and my students might want or need. This fact was tremendously liberating. If ISIS did not do what we wanted it to do, we fixed it—over and over again. And, with an early version of ISIS in place, I began to consider how I would actually teach with MESL images.

The Center for Teaching Excellence at the University of Maryland has, for a number of years, encouraged faculty to design courses that emphasize collaboration among course participants and interactivity with course materials. The MESL project, in combination with other instructional technologies available at the University of Maryland, provided a unique opportunity to pursue these goals. Over the last two years I have taught three different courses, each designed around MESL images, in our AT&T Teaching Theater (see Figure 1).[2] In this article, I will focus my attention on the two undergraduate courses.

▶ **FIGURE 1** Class session, "American Art to 1876," in the AT&T Teaching Theater, University of Maryland, Spring 1997

► "American Landscapes : Art and Technology"

"American Landscapes: Art and Technology," offered in the fall of 1995, used somewhat unconventional means to teach two fundamental art historical skills: visual analysis and contextual analysis. This first classroom application promoted collaboration both among art history students enrolled in this "American Landscapes" course and between these students and Professor Terry Gips's art studio students in the course "New Technologies and Their Impact on Visual Art."[3] While the two participating classes of art and art history students met independently, in different places and at different times, the collaborative projects outlined here were constructed to bring art and art history students together around a set of shared educational goals. Early in the semester, I selected five MESL images in local collections and assigned one of the five images to each of five student groups. These groups were designed to include individuals with a range of art historical and technical experience. Working with the original paintings in the local museums (the National Gallery of Art and the National Museum of American Art), the art history students wrote visual analyses of the images. Selections were limited to *local* collections because the analyses themselves necessarily involved the originals, not the digital reproductions. The analyses the art history students produced were then passed on to Professor Gips's art studio students, who, on the basis of the written descriptions and without knowing the identity of the work, created "visual correlates" using basic computer graphics software. The next step brought students from both classes together to identify the original image and to compare its digital MESL reproduction with the student-created visual correlate (see Figure 2).

Discussion of the challenges presented in "translating" from image to text and back again followed, as did further exploration of the visual character of the five MESL images. Using a variety of electronic tools, students subsequently produced various "manipulations" of the MESL reproductions in an attempt to better understand the significance of the choices the artists made in creating the originals. Students were asked to consider how the impact of the work might differ if color, contrast, orientation, etc. were altered or if new elements were introduced into the composition.

 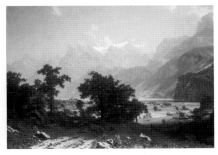

► **FIGURE 2** (*left*) Visual correlate created by Eleise LaPorta, Fall 1995, derived from a
visual analysis of (*right*) Albert Bierstadt's *Lake Lucerne*

Art history students then took their work with the selected images a step farther, by examining the contextual histories of the images and presenting their research in class. With this contextual information in hand, they returned to the computer lab with their art studio counterparts and adjusted some of their manipulations. One group of students, intrigued by Thomas Cole's interest in geological theory and its relation to the biblical text from which he drew his subject, transformed all of the water in *The Subsiding of the Waters of the Deluge* into molten lava (see Figure 3 on page 16).

▶ **FIGURE 3** (*left*) Image manipulation created by Jelili Salako, Fall 1995, derived from
(*right*) Thomas Cole's *The Subsiding of the Waters of the Deluge*

Finally, all of the images (the MESL "originals," the visual correlates, and the subsequent manipulations) were mounted on WebChat, where electronic conversation about the process could continue outside of class in a format that accommodated both image and text and allowed students to create links to other relevant sites.[4] In relation to a discussion of Alvan Fisher's *General View of Niagara*, for example, one student (after seeking appropriate permissions) incorporated links to a range of sites dealing with Niagara Falls. Although it was introduced late in the semester, WebChat offered students a much-needed option for "online" discussion of course work and, most important, for making visual images part of the informal "chatting" of the class. The fact that students could participate at any time of day and from any campus location helped alleviate some of the logistical difficulties associated with collaborative and interactive learning. The process was casual and immediate and facilitated spontaneity as well as thoughtful reflection on course content.

▶ "American Art to 1876"

At the University of Maryland (as at other institutions), new electronic media for organization and presentation have encouraged a number of faculty members to rethink the course syllabus. In the spring of 1997, the syllabus for "American Art to 1876," for example, became a course Web site, an electronic document incorporating words and images, available 24 hours a day from any location on campus. When students accessed the site, they found a home page (see Figure 4) that indexed resources for use inside and outside class and included links to, for example, a MESL Web-based search engine; the syllabus proper; an archive of in-class electronic conversations; and the pages for the semester's major project, the *Class Exhibition*. For each image on the Web pages, students could, with a click of the mouse, move to thumbnail reproductions accompanied by identifying text or to larger-scale digital reproductions of the work of art. *Course Calendar* pages offered students immediate access to the images assigned for in-class discussion, an illustrated glossary of terms, and archives of visual materials from each lecture for review outside of class.

The *Class Exhibition* page (see Figure 5 on page 18) contained links to MESL images currently on exhibition in local MESL institutions. The three major writing assignments for the course were associated with images on this Web page. First, students were asked to go to the appropriate institution and do a visual analysis of the original painting they selected from the list. Later in the semester, still working with the same image, students were asked to write a contextual/historical paper. Finally, they were invited to refine their thinking in relation to the idea they found most compelling or coherent in their visual and

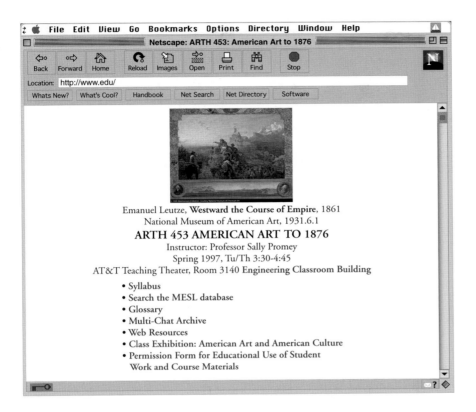

► **FIGURE 4** Home page, "American Art to 1876," course Web site, Spring 1997

contextual analyses and to write an "exhibition catalog essay" that would be linked to the image on the *Class Exhibition* page. The final exam for the class encouraged students to think synthetically about course content in relation to a number of MESL images not included on the *Class Exhibition* page.

Two especially productive technological applications in "American Art to 1876" allowed students a more direct and intimate engagement with images than conventional classroom media for art historical instruction generally provide. The first of these applications involved the organization of visual information and the use of electronic conversation software called MultiChat to facilitate in-class discussion of assigned readings. During class sessions, students worked in small teams gathered around computer workstations (see Figure 6 on page 19). They kept at least two windows open on their monitors throughout the session: One framed the image or images under consideration, and the other allowed access to a MultiChat document containing a set of questions I had entered before class. Because I value face-to-face conversation as an instructional resource, I integrated the use of the electronic chat package with open conversation among course participants. This combination of written and oral in-class communication produced a situation in which, on any given day, 85 to 90 percent of students contributed meaningfully to the discussion, a significant increase over the 15 to 20 percent I have come to expect in a more conventional classroom. Because MultiChat makes it possible for students to see each other's comments as well as their own, they were diligent about completing assigned readings and preparing for discussion sessions. Because they worked in small groups and had a chance to refine their comments before entering them, students were less intimidated when it came to expressing their ideas. Furthermore, the immediate proximity of relevant images made

it possible for both students and the professor to ask very precise questions of the visual material. In addition, students who wanted to return after class, and throughout the semester, to the content of the electronic conversations had only to visit the MultiChat Archive on the course Web site.

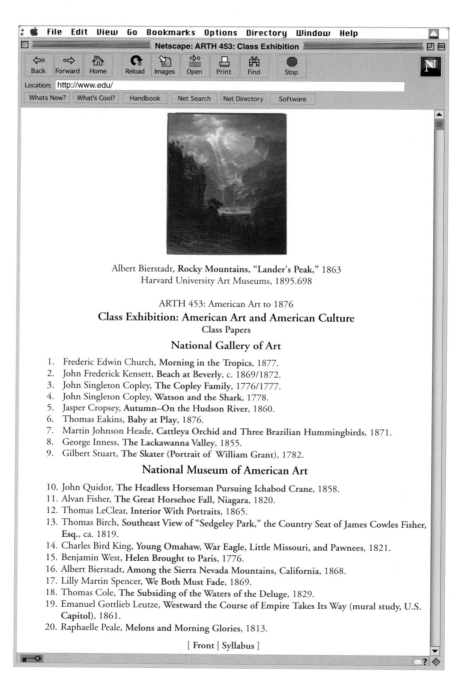

▶ **FIGURE 5** *Class Exhibition: American Art and American Culture* page, "American Art to 1876," course Web site, Spring 1997

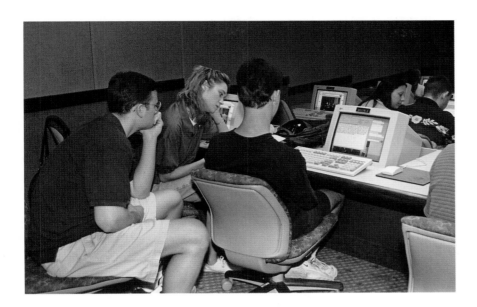

▶ **FIGURE 6** Discussion session, "American Art to 1876," in the AT&T Teaching Theater, Spring 1997

From the students' perspective, a second particularly fruitful application invited them, like students in the earlier "American Landscapes" course, to *work with* reproductions of works of art as well as to *look at* them. Early in the planning for the MESL project on our campus, one member of the art history faculty, Professor Josephine Withers, began assembling a set of demonstration modules for visual analysis (see Figure 7). Computer graphics

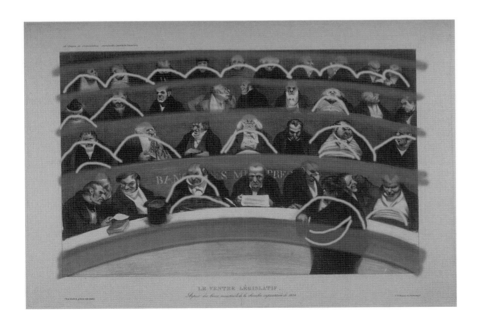

▶ **FIGURE 7** Visual analysis demonstration module depicting visual rhyming, Spring 1996. Based on Honoré-Victorin Daumier's *The Legislative Belly (Le Ventre Législatif)*

software enabled her to create digital "transparencies" that overlaid relevant compositional information on a number of the digital reproductions made available by MESL institutions. She mapped out, for example, the perspective systems of selected images and the use of visual rhyming.

Since composition is one of the areas in which beginning students in the discipline acquire skills slowly, our initial thought was to use these modules with small discussion sections of the large introductory art history lecture courses—and we did, in fact, use them first with a self-selected group of students from one of our undergraduate art history surveys. The results of this "trial run" were promising and, with the demonstration modules in place, we took the next logical step. With my supervision and that of Catherine Hays, Coordinator of Digital Technology and Electronic Media in the College of Arts and Humanities, students in "American Art to 1876" used computer graphics software installed in the AT&T Teaching Theater to create their own digital transparencies. Using this approach, each student explored in class the visual and compositional elements of the image that formed the basis of her/his semester's research. The most valuable aspect of this exercise was not the pursuit of a particular product—"the perfect overlay"—but rather the process of learning to understand composition by working directly on the reproduction.

▶ Student Response

Because of evaluation procedures already in place in most universities, audience response in this institutional context is relatively easy to assess—and the reactions of students to date will be reassuring to art professionals in both museum and academy. Beyond their enthusiasm about the availability of electronic resources at any hour, inside or outside the gallery or classroom, students at the University of Maryland report that the physical proximity of the image on their own computer screens diminishes the remoteness of the object and enhances their sense of personal connection to the material. With surprising frequency, this heightened familiarity leads them into the museum to see "their" work of art. The use of digital reproductions in the classroom, then, also increases the likelihood of students' engagement with the original artwork, breaking down barriers some initially feel when contemplating visits to museums to see works of art. Students are thus motivated to move out of the more regulated and sometimes passive conventional learning environment and to participate actively in shaping their own education.

As a group, art professionals seem to ask two apparently contradictory things of digital images: We want them to contain as much visual information as possible (reflected in our concern with resolution and quality of scan) *and* we want students to acknowledge digital images as reproductions, distinct from original works of art. If the classroom experiences of the art history faculty at the University of Maryland over the last two years can be taken as a reliable indicator, we may well be able to maintain a workable balance between these two demands. This technology appears, in fact, to reinforce students' understanding that they are dealing with mediated information. They recognize and articulate the artificiality of the video screen regardless of the quality of the reproduction. Many report a renewed joy of discovery in the presence of the original, based in part on their sense of the degree of contrast between the actual object and its high-quality digital version.

▶ Summary and Conclusions

At the heart of the MESL project has been the idea of collaboration: among students in a single course and in different courses; between different professional constituencies in a single institution; and between the two principal types of participating MESL institutions. The possibilities for new intra- and extra-institutional alliances raised in the course of this project are especially exciting. As scholars and educators in museums and universities, we share commitments to the preservation, elucidation, and interpretation of visual cultural heritage. There are many issues yet to resolve, including questions of intellectual property rights, quality of reproductions, equality of access across economic barriers, technical obstacles, and variations in skill and comfort levels. But significant conversations have begun, and art historians in a number of arenas are accumulating enough experience to make helpful decisions.

For if we learned anything in the course of the MESL project, it is that we *do* need to make decisions. If the technology is to serve our discipline, our research, and our educational programs, we must become involved in such formerly non-art-historical tasks as the development of software. This is not to advise that we learn a second vocation and become technical specialists capable of creating the programs ourselves; rather, it is to suggest that we collaborate with instructional technologists to discover what we want electronic media to do for art history and to help ensure that our designs are implemented. The increased exposure to high-quality reproductions promised by this newest visual revolution can invigorate scholarship in the museum and the academy and create new audiences for works of art and the institutions that hold them. It is not enough, however, to simply have the information; it must be organized in meaningful and substantive ways. The question of what to do with information once we have it carries with it a range of intellectual, political, social, and ethical implications and concerns. As educators in the museum and the academy, we have an opportunity to take responsibility for the content we value and want to share.

▶ Acknowledgments

Many people worked together to make possible the technological investigations described in this article. Academic Information Technology Services, the College of Arts and Humanities, the Office of Undergraduate Studies, and the Center for Teaching Excellence have devoted considerable resources and energy to the MESL project. I am especially grateful to Ellen Borkowski, C. S. Chang, Maria Day, Sharon Gerstel, Walter Gilbert, Meredith Gill, Terry Gips, James Greenberg, Quint Gregory, James F. Harris, Catherine Hays, Susan Jenson, Sarah Miller, William Pressly, Adele Seeff, Josephine Withers, and Lynne Woodruff. Among the faculty, four professors (Meredith Gill, William Pressly, Sally Promey, and Josephine Withers) in the Department of Art History and Archaeology and one in the Department of Art (Terry Gips) taught one or more courses that incorporated MESL images; three interdisciplinary team-taught humanities courses, coordinated by the Center for Renaissance and Baroque Studies in the College of Arts and Humanities, used MESL reproductions. In the absence of MESL images in her field of specialization, one professor of Byzantine art (Sharon Gerstel) developed a course and designed a Web site around a large

number of images for which she held copyright; she also secured permission from Dumbarton Oaks to include digital reproductions of many objects in their collection. In addition, two other members of the art history faculty (Jane Sharp and Ekpo Eyo) began designing digital instructional materials in response to the MESL project.

▶ Notes

1. According to the MESL agreement, all materials are located in a secured area restricted to the campus and to other MESL institutions. While most materials in this experimental project are not publicly available, every MESL institution (museum and university) has access to the products of every other MESL institution's efforts.

2. Each student in this technology-rich learning environment sits at a computer workstation with the monitors recessed to preserve sight lines in the room.

3. Portions of the text that follows have appeared elsewhere; see Sally M. Promey and Miriam Stewart, "Digital Art History: A New Field for Collaboration," *American Art* 11, no. 2 (Summer 1997): 36–41.

4. WebChat was developed late in the semester as a tool that would allow students in these two courses to organize the visual materials with which they had worked over the course of the semester and to converse with each other outside of class about aspects of their projects.

.·.

A New Culture of Learning:
Courses in Nineteenth-Century
Art Using Digital Images

LAURA L. MEIXNER

I incorporated the Museum Educational Site Licensing Project (MESL) digital images into the curricula of two advanced-division lecture courses in the Department of the History of Art at Cornell University: "Painting and Everyday Life in Nineteenth-Century America" and "Impressionism in Society." Each course included advanced undergraduate and graduate students, and majors in the history of art as well as in the allied humanities fields. Students represented the departments of comparative literature, romance studies, theater arts, government, history, and the American Studies program. Also enrolled were adult students, including university employees and docents from the Herbert F. Johnson Art Museum.

Through the common theme of art and daily life, both courses sought to place art history within the broader contexts of visual culture and interdisciplinary studies. Students examined how images acquire multiple meanings across time and place in response to cultural differentials, such as the class status of the artist and interpretive groups (elite, middlebrow, worker) or the sociopolitical setting of the work of art (capitalist, anarchist, utopian, socialist). Readings and class discussions considered political, literary, and technological influences on visual culture, with an emphasis on cross-class and cross-national reception among nineteenth-century and present-day audiences. Lectures and term paper projects were designed to encourage an open-ended definition of art, including broadsides, ephemera, advertising, political cartoons, playbills, and fashion plates.

By blending material culture and the fine arts, students formed their own theories concerning the cultural constructions of gender, race, and nation, as well as definitions of consumerism, spectacle, and commodity. The arrangement of the course lecture material, therefore, was thematic rather than chronological. In each course, students viewed approximately 100 MESL images outside the classroom. Although the assignments and material differed, the chief objective was to extend classroom lectures into student dialogues.

▶ "Painting and Everyday Life in
Nineteenth-Century America"

This course was designed to discuss American art and theories of national identity. Therefore, the course description was organized around Alexis de Tocqueville's philosophy of "exceptionalism":

> Nineteenth-century American painters often constructed images of "exceptionalism," Alexis de Tocqueville's term for the social harmony and material abundance he considered unique to the New World. Embedded in these icons of national cohesion were signs of race, class, and political conflict that we will decode through interdisciplinary methods. Topical units include: New England portraiture and commodity, Hudson River landscape and corporate patronage,

images of African-Americans and Reconstruction, and images of Native Americans and Manifest Destiny. Through these units of study, we will examine the assumption that American art celebrated democracy and consider more conflicted attitudes, including issues of cultural chauvinism and inferiority. Our key artists include John S. Copley, Thomas Cole, Lily M. Spencer, and Albert Bierstadt. In addition to art historical texts, our readings include Walt Whitman's *Democratic Vistas* (1871) and Jean Baudrillard's *America* (1988).

The MESL study guide was arranged by genres: literary tales, portraiture, landscape, and common life. Study questions accompanied each thematic set or pair of images. Derived from assigned readings and classroom lectures, the questions were primarily to assist students in preparing for midterm examinations. However, the questions were deliberately broad, designed to accommodate several interpretations and promote group discussion. For example, the first set of images in the study guide, John Quidor's *The Headless Horseman Pursuing Ichabod Crane* (National Museum of American Art) and *The Return of Rip van Winkle* (National Gallery of Art), encouraged students to consider the literary, illustrative beginnings of genre painting in America (see Figure 1). From there, they went on to compare Quidor's images and Irving's texts, then identify larger cultural issues, including the importance of folklore and oral tradition to regional identity in America. They further discussed how folklore and history represent different levels of societal truths.

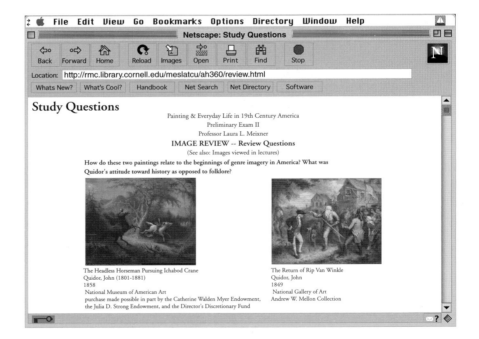

▶ **FIGURE 1** Sample review question for the course "Painting and Everyday Life in Nineteenth-Century America"

The MESL database also allowed my students a much larger vision of a particular artist's *oeuvre* than I could have otherwise provided, given the time constraints of the semester. Because students were able to access several images by an artist, Asher B. Durand, for instance, they began to develop skills in attribution. By the end of the term, they were

able to identify certain compositional signatures, a skill they applied while visiting the American art collection of the Herbert F. Johnson Art Museum. Moreover, because the MESL project provided a flexible selection of images, students were able to view Durand and other Hudson River painters alongside important source material, including the work of John Constable. Once students connected the visual elements of the Hudson River school and the Barbizon school, for example, they went on to form theories concerning the democratic ideologies of American and French landscapes. Because they had simultaneous access to several images, my students also acquired a better understanding of the importance of the multi-panel cycle to American visual culture and poetry, as exemplified by Thomas Cole. By comparing *The Pilgrim of the Cross at the End of His Journey* (National Museum of American Art) to cycles such as the *Voyage of Life* (National Gallery of Art), students gained an awareness of painting as narrative text and the importance of allegory to nineteenth-century American culture (see Figure 2).

► **FIGURE 2** Thomas Cole review question

The simultaneous viewing of several images (as opposed to the comparative format of two slide projectors) proved a valuable teaching tool. When students studied groupings of images, they not only developed a keen sense for a particular artist's style, but also became much more aware of the ways in which types of images, such as photographs and paintings, together constituted the nineteenth-century vision of America. This was particularly evident in my students' work on images of the American West as the New Eden. By discussing the compositional formats they observed in the MESL images of O'Sullivan photographs and Moran paintings (National Museum of American Art), they were able to identify characteristics designed specifically for East Coast, middle-class audiences. Thereby, my students arrived at conclusions concerning the pictorial marketing of the West, which they applied in inventive ways to present-day examples, including the popular film *Dances with Wolves*.

Clusters of images also led my students to examine different regional/national ideologies in the works of several artists. By comparing Inness, Cropsey, and Durand, they identified distinct political programs related to exceptionalism. In some cases, students used questions and images from the study guide as a point of departure for term paper topics. Beginning with Inness's *Lackawanna Valley* (National Gallery of Art) and Cropsey's *On the Hudson River* (National Gallery of Art), one student developed a paper on the changing paradigm of the pastoral during the epoch of transition into industrial capitalism.

The advantages of using MESL images became immediately apparent. Lively groups of students looking at clusters of images and sharing ideas now replaced the traditional method of review that obliged a student to sit silently before a rotating drum of slides. What resulted was a genuine collaborative purpose among the students (undergraduate majors and non-majors) who studied together. Competitive attitudes toward grades gave way to shared ideas, and that sense of intellectual community carried over into classroom discussions. Also advantageous was the fact that students were no longer bound by slide library hours or limited to a single midterm review session; the learning/review process took place continuously throughout the semester. With computer stations available in Cornell's Sibley Fine Arts Library, students were able to combine their use of MESL images and course reserved readings. They also became increasingly skilled at using online reference tools— *International Repertory of the Literature of Art* (RILA), *Art Index*, etc. I soon recognized that students were able to depart from short-term memorization of images for exams, and now worked toward greater focus, concentration, and retention of visual materials. Consequently, they approached the material with confidence and enthusiasm.

▶ "Impressionism in Society"

As the following description indicates, this course discussed French Impressionism as it relates to nineteenth-century public life:

> Images by Manet, Monet, Cassatt, Seurat, Degas, and Toulouse-Lautrec. Images are interpreted as cultural products of the Third Republic, with close attention to café and brothel society, middle-class leisure, and workers' movements. Woven into historical discussions are theoretical considerations of the *flaneur*, utopia, capital, pathology, and the public body. Issues of class, gender, and power are addressed through the writings of Baudelaire, Benjamin, and Zola.

For this course, Nancy Green, curator of prints, and I first arranged the exhibition "Modern Life in France" at the Herbert F. Johnson Art Museum; then Noni Korf Vidal, curator of visual and electronic collections, established our MESL site and a computer kiosk in the gallery. The Johnson exhibition included examples from the Barbizon and Impressionist schools, as well as French photographs and Japanese prints. Among the artists represented were Millet, Daumier, Cassatt, Degas, Sargent, and Signac. The Johnson exhibition comprised works on paper (prints, photographs, and drawings), which I complemented with selected MESL images of paintings. Along with a bilingual text (French and English), our MESL site displayed images arranged as virtual galleries. The chief themes included "Prints and Politics," "Bathers and Brothels," "Public Spectacles," "Transport, Trade, and Technology," and "Rural Labor, Urban Market." Each student chose an original work from the Johnson exhibition as the focus of his/her term paper, then contextualized the image while positioning it within the artist's *oeuvre*. Student approaches varied from political emphases to gender studies.

The MESL site figured directly in the term paper project. The site allowed students an immediate view of the evolution of Impressionism, and thus a framework for their term

paper image. The point was not simply to provide larger numbers of images, but to give students a sense of the historical development of Impressionist styles and themes. This was particularly beneficial to those students with little background in the history of art. For example, "Coastal Views" provided a cross-section of seascape images that included both French and American artists, and ranged from Realism to Neoimpressionism. The gallery "Prints and Politics" included images by Rembrandt, Goya, and Daumier. Thus, students were able to discern the art historical sources for Manet prints, such as the *Absinthe Drinker* (1862), included in the Johnson exhibition. They further made connections between the Baroque and Impressionist traditions of prints as social commentary. One student paper based on the *Absinthe Drinker* creatively traced Manet's figures of indigent Parisians to seventeenth-century origins while discussing the issues of absinthe consumption in the Third Republic. Another related Manet's *Les Gitanos (The Gypsies)* (1862) to the artist's self-fashioning as a bohemian outcast. One of the most popular MESL galleries was "Public Spectacles," comprising images of paintings by Cassatt, Degas, Toulouse-Lautrec, and Seurat. Several students analyzed the contrasting ways these artists approached the theme of public theater, then related their findings to the Toulouse-Lautrec poster on exhibit, *Le Divan Japonais* (1892–1893). The results were a number of inventive gender-based analyses of the marketing of women performers in a capitalist culture.

Our combined use of an exhibition dedicated to a history of art course and a MESL virtual gallery drew the attention of students from other areas of the humanities who visited the Johnson Art Museum. Undergraduate majors in comparative literature toured the exhibition and the MESL site with my students. Together, the students recognized ways to integrate visual culture and their studies of Baudelaire, Zola, and Mallarmé.

▶ Post-MESL Conclusions

I believe that ready access to digital images will open more avenues for cross-disciplinary teaching and research. Collaborative projects with the Departments of English, History, Music, and Anthropology are only a few possibilities. The overall advantages I recognized in introducing MESL images into my classroom include a departure from canonical images and the accessibility of larger numbers of images from diverse epochs. The ability to draw on source material from different periods simultaneously was central to my students' understanding of nineteenth-century art. Most significantly, in my view, the MESL sites facilitated student intellectual exchange outside the classroom. Communication became more fluid, and the students themselves created their own culture of learning in which they shared knowledge across the disciplines.

From my perspective, the lasting impact of the MESL project is evident in my students' increased visual acuity, retention, and awareness of visual culture in its diverse forms. The visual stimulation the MESL project provided led students to look further—at original works, textual illustrations, slides, and study prints. As their interest in visual texts grew, so did their research skills and creativity. Because the MESL sites extended the learning experience and discussion outside the classroom, students gained more time to reflect on the complexities of their projects or study questions, and thus develop more thoughtful approaches to their work. What I hope to see in the immediate future at Cornell are opportunities for interactive projects that might combine the function of a study guide with the dynamics of a chat room. Also, I would like to assign my students a virtual exhibition project for which they would design the installation and select the images. They might work in collaborative groups, then present their exhibition in class along with research justifying their choices.

·:

Integrating Licensed Images
into a Digital Library : Access and
Resource Management Issues

DAVID MILLMAN

The experience of the Museum Educational Site Licensing Project (MESL) has contributed valuable insights toward the future of distributed digital collection architectures. This paper reviews the MESL architecture model and its relationship to prevailing Web practice; discusses the impact of architecture models on the user, the library, and the content provider; and suggests directions for future work.

▶ The MESL Model

After initial discussion early in the MESL project, the following model was used: The content suppliers (the museums) sent their contributions of digital material to a central distribution service, from which copies were made and forwarded to each of the participating universities. Each university was then responsible for making the MESL collection available to its user community.

Museums generally supplied two kinds of data: digitized images and descriptive metadata—information that describes the image content, similar to a library bibliographic record. Each metadata record usually corresponded to a single image, and a special field identified the file name of the image corresponding to the metadata record. While the metadata form was agreed on in advance by all participants, each supplier used independent local conventions for file names.

All receiving universities then independently established the MESL collection locally as a single electronic resource, often distinct from any other institutional digital collections; almost all provided the collection using World Wide Web technology. In other words, the universities generally created local MESL Web sites.

This model has been successful because it divides labor effectively in a context of as-available standards. Museums conformed to currently stable image formats and, at least temporarily, to an agreed-on metadata format. Each university developed and maintained its own site integration, interface design, and security provisions (areas in which there is little agreement but active development); each university also established independent support channels, providing detailed feedback to those involved with the local site development as well as to those responsible for project-wide planning.

▶ Architectural Impact

The success of the MESL project can be attributed to its excellent project-wide coordination and enthusiastic institutional support, culminating in the delivery of a tangible

scholarly resource. But its participants now enter a challenging period as they confront the issue of large-scale implementation. Can the MESL architecture accommodate terabytes of digital content, thousands of content suppliers, and millions of consumers?

The MESL architecture demands that duplicate copies of the entire collection be stored at each university. It demands duplicate labor at each university for installing the images, maintaining the metadata, and integrating the two into a comprehensive collection. It demands a central redistribution facility. While the MESL architecture relies on the university network for the ultimate delivery of digital content from campus library to individual, it does not otherwise take advantage of network technology to distribute costs.

Meanwhile, over the course of the project, several museums have independently established their own Web sites. This alternative architecture removes many of the duplication issues above. Content and metadata are stored and supported only once, at the individual museum site; no redistribution facility is needed. On the other hand, these sites have duplicated the costs of establishing Web sites, including the labor to build independent interfaces, as well as navigation and searching tools. And, there is currently no way to search or navigate these separate collections as a whole.

The MESL group did discuss an intermediate solution in which the entire MESL collection would be housed at a single site. In this case, the collection could be searched and navigated consistently and without duplication of storage or site development labor. (Mirror sites could also be established to assist in performance and reliability.) In fact, this model could have been implemented with a different balance of contributed resources and coordination. But rarely does any single site satisfy all the needs of an individual, much less the needs of the complex scholarly communities served by research libraries.

Digital collections on the Internet almost universally follow the "collection-as-Website" model. Customers experience the collection in the context of the site: They learn and use the site's distinct menu styles and its search and navigation tools. They must find the site initially in order to use the collection it contains. As individual sites grow, mature, and reorganize, users must adjust to or relearn known collections; as new sites appear, users must continuously search for and evaluate them. Widespread complaints about the disorganization and inconsistency of the Web stem largely from this dynamic and distributed architecture. Indeed, the resources saved by such distributed collections may be at the expense of customers' time and effort in learning to use them, discovering new ones, and discarding inferior ones. Collections embodied as distinct Web sites are rampant, but are not scaled to serve the needs of users.

▶ Granularity of Digital Objects

One way to develop a more flexible architecture is to approach the collections in the opposite order: Begin with the digital objects desired and work outward to organizations of these objects. For the MESL project, the digital object is most often a single image, a work of art. At Columbia, we have collections in which the ultimate digital object is a Web page that contains both an art image and a mechanism for retrieving several different screen resolutions or detailed views of it. In addition, we have collections of digital monographs in which book chapters are discrete digital objects; we have digital reference works in which each single encyclopedia entry is a distinct digital object. These models are not restricted to image collections. The universe of networked resources across the Internet may be considered a vast set of digital objects, from journal articles to rail schedules to film clips to chat rooms.

What are the characteristics of a digital object? At what level of detail may one define a digital object? To extend the example mentioned above, Columbia has a distinct digital

object for the Parthenon, which retrieves a Web page containing many different images—views from different angles and distances. Why not identify each of these as a digital object in its own right?

Initially, I define a digital object as a networked resource with two requirements:

1. It has a unique name, an identifier, by which it may be retrieved from anywhere on the network (a URL, for example).
2. It has a well-defined and "seamless" method of being presented to users.

Given these requirements, questions of granularity are largely subjective. For example, if I assign a unique network name to a particular detailed view of the Parthenon, and if that name retrieves, say, an image in the JPEG format, it can be immediately presented and can therefore be a distinct digital object. Or if I assign a unique name to the Parthenon collection and that name retrieves the Web page as above with many different images, it can be a distinct digital object, too. For the MESL project, an appropriate digital object might be a Web page containing a single image and the required conditions of use statement.

In such a model, collection developers would need to make judgments about the level of detail appropriate for their particular collections. Also, they must be willing to invest in establishing metadata fragmented at the same level of object detail. The degree of fragmentation chosen may have a strong impact on the accessibility of the collection. For example, choosing large fragments implies fewer ways of looking at discrete components. For objects such as multimedia or SGML works, which may now require specialized presentation (or "helper") software that is unable to distinguish fragments, discrete retrieval of small components may not even be possible.

Discovery and indexing of the MESL collection could be very similar under this initial model to what was, in fact, used in the project. The MESL descriptive metadata could be duplicated or centralized, merged with other metadata, sorted, reorganized, and made searchable in various ways. The difference would be that, in place of the file name, the digital object identifier would be used to retrieve the item content. The collection itself could be widely distributed, centralized, or any combination of the two. There need be no MESL "site"; the content may be anywhere on the Internet. MESL's distinction as a collection would only be through the "coincidence" of this particular set of descriptive metadata.

Site organization and navigation for collections such as MESL thus become issues of descriptive metadata manipulation only. Because descriptive metadata is much smaller than digital objects, there are many new opportunities for large central catalogs, smaller specialized catalogs for certain populations, or personal catalogs (similar to the now common Web bookmarks).

But this model does not satisfy a number of other longer-range requirements for a more general-purpose architecture. Several extensions would be needed.

► Intermediary Services and New Metadata

Digital object identifiers should refer to the digital content without regard to its physical location on the network. There has been broad discussion and increasing agreement that identifiers for digital objects should work the way International Standard Book Numbers (ISBN) work for books: pertaining to content, not to particular instantiations of it. A number of schemes are in development, such as Handles, Persistent Uniform Resource Locator (PURL), and Digital Object Identifier (DOI). These methods are best described elsewhere (see *www.handle.net, www.purl.org, www.doi.org*, and *www.internic.net/ietf/urn*). Briefly,

The Maryland Interactive System for Image Searching : Implementing a System to Facilitate Teaching with Digital Images

ELLEN YU BORKOWSKI AND CATHERINE HAYS

► Overview

The Maryland Interactive System for Image Searching (ISIS™) was developed through a collaborative process driven by the pedagogical goals of faculty members using the digital image collection of the Museum Educational Site Licensing Project (MESL). The Teaching Technologies staff in Academic Information Technology Services (aITs) at the University of Maryland, College Park, worked closely with faculty and members of the Maryland MESL project team in an iterative process spanning two years to develop these software tools. ISIS allows faculty to search the MESL database and select images for class lectures using the metaphor, familiar to art historians, of 35 mm slides spread across a light table. Images are selected for display following a dual slide carousel model and projected in the classroom using the ISIS utility ProjectImage™ or the World Wide Web. In addition, ISIS allows access to the data associated with the MESL image collection, such as curatorial notes and bibliographic information, and provides a visual sorting capability for research and analysis. Future plans for ISIS include porting the capability to a Web-based tool to support multi-platform use and possible interdisciplinary campus projects and cross-institutional collaborative projects.

► Background Information

The environment at the University of Maryland fostered the collaboration that led to the successful development of ISIS. There was strong administrative support from the Director of aITs, which houses the Teaching Technologies unit, and from the Dean of the College of Arts and Humanities. In addition, all members of the project team were committed to the project and motivated by individual professional interest. As a department, aITs has a customer-oriented philosophy and strives to provide high-quality services. Throughout the development process, the Teaching Technologies staff continually asked for feedback from faculty using ISIS and reinforced this request by integrating changes rapidly. As a result, the faculty became personally invested in the software and spent a great deal of time working through iterations. The project became a parallel discovery process, with the Teaching Technologies staff learning progressively more about how art history faculty work and the art history faculty developing a progressively greater understanding of the possibilities offered by technology.

The development of ISIS was an open-ended process in which a variety of university professionals collaborated: programmers, faculty from the College of Arts and Humanities, educational technologists, slide curators, art librarians, and administrators. Throughout

the project, significant collaboration took place between the Teaching Technologies staff and the art history faculty, a primary user of the MESL collection. In particular, Professor Sally Promey was committed to using the collection of digital images and related data the first semester (fall 1995) of the MESL project to teach an undergraduate course called "American Landscapes: Art and Technology." The course was held in one of the University of Maryland's Teaching Theaters, which are technology-rich classrooms that provide computer workstations on student desks and proprietary software to facilitate collaborative work and various means of communication. This was Professor Promey's first experience in a technology-oriented classroom. She was interested in teaching with digital tools to develop a clearer understanding of the medium. This experience would better equip her, she felt, to contribute to the design and functionality of tools yet to be developed. Although this was unfamiliar territory, she could envision opportunities offered by working with representations of art in a digital format, such as the pedagogical benefit of projecting images not preselected for a particular lecture. Like many of the members of the MESL project team, she was unable to articulate a description of the ideal tool for interacting with the image and data collection, but welcomed the opportunity to respond to possible models.

In addition to collaborating with the art history faculty, the Teaching Technologies staff also worked closely with the slide curator and chair from the Department of Art History and Archaeology to change the terminology of the MESL data dictionary, the standardized list of fields into which contributing institutions would import their data. It was anticipated that integrating the current art history slide indexing system and the MESL database would allow more images to be added in the future. Therefore, MESL field names were shortened and changed to match the existing slide library database more closely. Having the programmer collaborate with the content experts ensured that the language would be familiar to the tool's primary users. For example, the field entitled *creator/maker* was changed to *artist*, and *concept/subject* was changed to *keyword*.

The success of this process was due to the flexibility of the Teaching Technologies staff and the commitment of faculty and content specialists using the collection. This collaboration reinforced an exchange of ideas between the developers and the users and strengthened the development process.

▶ Software Requirements and Development Decisions

Many factors contributed to the decision to develop a proprietary tool rather than use a commercially available software solution. The Teaching Technologies staff has a history of developing software solutions for instructional use by faculty. The staff recognized the need for a digital image retrieval system based on the method of slide retrieval with which faculty were familiar and comfortable. In addition, time was a significant driving force dictating many initial development decisions: Two classes were dependent upon the availability of the digital image collections by September 1995, yet the MESL project data and image collections were distributed to the college campuses in August 1995. The Teaching Technologies staff needed to quickly develop a tool to allow faculty to search the database, save a list of identified image files, and project selected digital images in the classroom. A tool was required that would perform the following functions:

- ▶ Import data files easily
- ▶ Link to images easily
- ▶ Provide a simple user interface to select images
- ▶ Support dual-screen display of different or like images

In addition, the various ways in which faculty would be using the images could not be anticipated. Developing proprietary software allowed the flexibility needed to change the user interface quickly and encouraged the faculty to explore new ways of interacting with the digital image collection. Because of these technical requirements and the short time available for implementation, the Teaching Technologies staff developed proprietary software by using (1) a previously developed digital image delivery system, called Caprina,™ as the underlying software architecture and (2) a development language with which the staff was already familiar, Microsoft Visual Basic for Windows.

▶ The Development Process

Owing to the immediate need for a more sophisticated tool with search and retrieval functions, the Teaching Technologies staff worked with minimal input from faculty to develop the first iteration of ISIS (see Figure 1). Caprina served as the starting point for ISIS by providing a set procedure and directory structure for accessing images. The formal database approach that was taken allowed searching any combination of the complete set of fields from the MESL data dictionary. This tool, used by Professor Promey for the first semester of the MESL project, required a great deal of intervention from the technical members of the project team. The initial interface was not intuitive, and Professor Promey interacted with the image collection and data using a script of instructions to retrieve the needed files and create image lists for class projection. Implementation of the first version of ISIS demonstrated that professionals in different fields operate under very different sets of assumptions.

ISIS's current simple query interface was developed as a result of a meeting between the Maryland MESL project team, the Teaching Technologies staff, and faculty using the collection. That meeting was the first opportunity for an extensive dialogue between the developers and the users. Professor Promey provided significant feedback after using

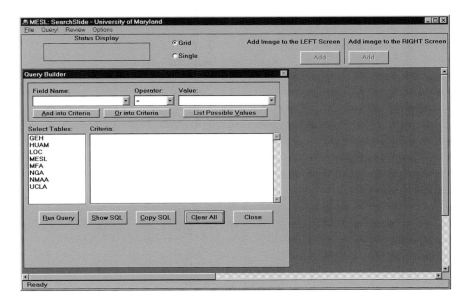

▶ **FIGURE 1** A sample screen from the first iteration of ISIS

the first version of the tool for a semester. After reviewing the tools developed by other institutions participating in the MESL project, project team members unanimously expressed the need for a more intuitive tool with a less daunting interface. In recognition that most users would not take advantage of the capability to search the collection using any combination of fields, selected fields and functions for searching were identified. At this stage in the collaborative process, it was significant that the developers expressed minimal resistance to change and were willing to create a new interface rather than make changes to the existing one. This reinforced the value of the users' involvement in the development process.

Functionality was added that had not been completed earlier because of time limitations. The metaphor of slides on a light table was achieved with the introduction of the ability to view thumbnails of the search results, drag thumbnails to the left-screen or right-screen presentation lists, view thumbnails of left- and right-screen presentation lists and adjust the order of images within the lists by dragging thumbnails to appropriate positions, and deleting and duplicating thumbnails. In addition, subtle revisions were made such as changing the display of the controls in the image projection software from "F" and "R," for forward and reverse, to up and down arrows.

After this major upgrade, feedback from faculty and graduate students continued throughout the following semester and resulted in incremental improvements to ISIS. Additional faculty were using ISIS, which also provided a new perspective. Graduate students were formally involved in the project through their participation in the graduate seminar "Art History and the New Technologies: Research, Teaching, and Communication" taught by Professor Promey. The students spent time both using and evaluating ISIS. As a result, new features were added and changes continued to be made to the interface. Functionalities specific to the art historians' use of the digital image collection continued to be identified. For example, the ability to add a blank screen to the image list for single-image projection in the classroom had not been anticipated by developers. The Teaching Technologies staff anticipated future needs such as exporting selection lists to HTML. This proved to be useful in posting images from lectures for review by students in "American Art to 1876" taught by Professor Promey during spring 1997. In addition, the current version of ISIS allowed Professor Promey to rely solely on digital images organized through the retrieval and sorting capabilities of the software for class lectures.

► Description of the Software

The software environment for the MESL project at Maryland consists of two main components: Maryland ISIS and ProjectImage. ISIS provides the search and presentation list-building functions for preparing images for delivery. ProjectImage provides the "projection" of the digital images in the classroom. In addition, images can be made available via the World Wide Web for student access outside of class.

Maryland ISIS

Maryland ISIS provides the ability to search the MESL database and to build left- and right-screen presentation lists of images. These left- and right-screen presentation lists allow for comparing/contrasting digital images side by side using ProjectImage, which is similar to the way art history faculty traditionally have presented images using 35 mm slides. When the software is launched, the user is presented with a simple interface (see Figure 2). The ISIS desktop is separated into two sections: the Simple Query window on the left half of the screen and the Selection Review window on the right half of the screen. Other windows displaying thumbnails, full database record information, and full-size images will appear

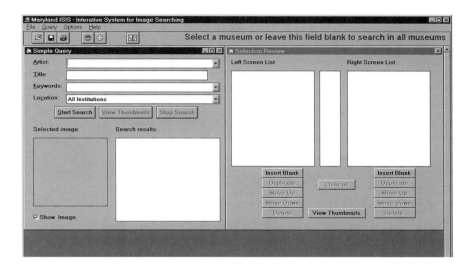

▶ **FIGURE 2** Opening screen for Maryland ISIS showing Simple Query and Selection
 Review windows

when a particular feature is selected. Context-sensitive help messages appear in the upper
right-hand corner of the main program window.

The Simple Query window is broken up into the search fields, action buttons, search
results, and selected image. The four fields on which the user can search are *Artist, Title,
Keyword*, and *Location*. The *Location* field refers to the MESL holding institution. The
Artist, Keyword, and *Location* fields have drop-down list boxes that contain possible values
for the field. The *Artist* and *Keyword* drop-down list boxes are context-sensitive and will
change on the basis of the location selected. For example, Figure 3 shows a portion of the
list provided for the *Keyword* field based on selecting "National Gallery of Art" in the *Loca-
tion* field. The user has the option either to select an item from the drop-down list or type
his or her own keywords.

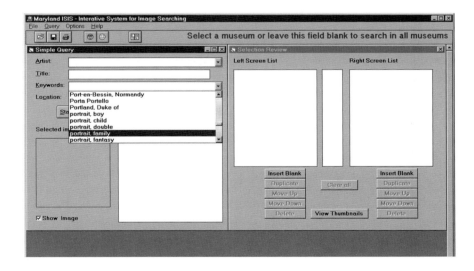

▶ **FIGURE 3** Partial listing of keywords available for National Gallery of Art location

Once the desired fields are defined, the user presses the *Start Search* button. A status bar will appear just below the *Start Search* button, indicating the progress of the search. As records are found, the titles of the images will appear in the *Search Results* box. If the user wishes, the search can be stopped at any point by clicking the *Stop Search* button. This is useful if the user already sees the titles of the desired images—the whole search does not need to be completed before continuing to the next step. Figure 4 shows the results of a search on the keyword "portrait" at the National Gallery of Art. The user can scroll down the list of image titles to find the desired image. As the user clicks on a title, the corresponding thumbnail of the image appears to the left of the *Search Results* box.

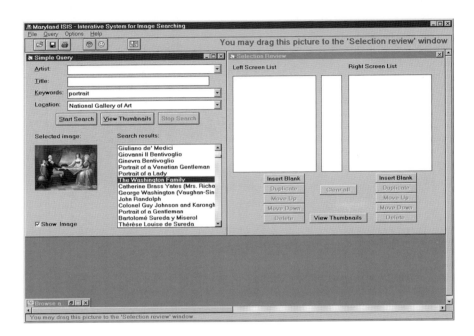

▶ **FIGURE 4** Results of a search on the keyword "portrait" at the National Gallery of Art

At this point, the user may either (a) view more detailed information on the image or (b) begin building the left- and right-screen presentation lists in the Selection Review window. To view more detailed information about an image, the user double-clicks on the title in the *Search Results* box. This opens another window that displays all the database fields and their values for the particular image (see Figure 5).

If accompanying documents, such as curatorial notes or exhibition history, are provided with the image, the *View Documents* button in this new window will become active. Clicking this button will open another window displaying the document's contents. If there are several documents, a drop-down box will list the titles (see Figure 6).

To build the left- and right-screen presentation lists the user clicks and drags the image titles over to the Selection Review window and drops them into the left- or right-screen box. Another option is to click and drag thumbnails of the images. To view the search results in thumbnail format, the user clicks the *View Thumbnails* button in the Simple Query window, which opens a new window with thumbnails of the images found in the search. As the cursor is moved over each thumbnail, its title appears in the lower left-hand corner of

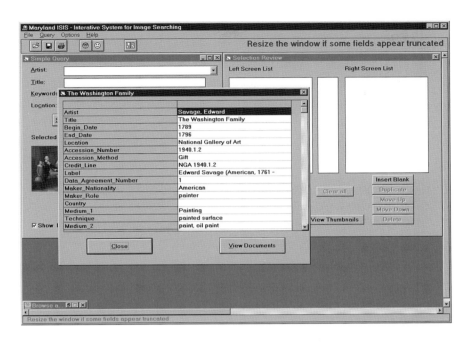

▶ **FIGURE 5** Detailed information displayed for an image

▶ **FIGURE 6** Accompanying documents for an image

the window. From this point, the user can click and drag the thumbnail to the Selection Review window and drop it in the left- or right-screen presentation list box (see Figure 7).

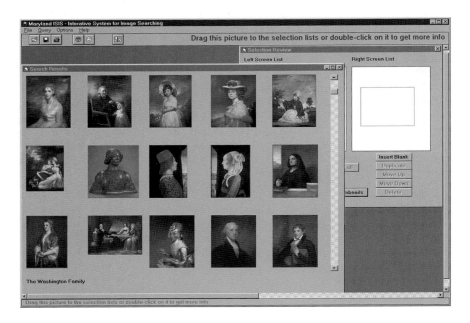

▶ **FIGURE 7** Selecting images identified by the search

At any point, the user may double-click on a thumbnail to see a full-size image and basic information about it (see Figure 8). To view the full record, the user clicks the *Retrieve More Info* button. Again, if accompanying documents are provided, the *View Documents* button will become active. Closing the information window or the full-size image window will bring the user back to the point of searching or building the left- and right-screen presentation lists.

As the user drags and drops the images into the Selection Review window, the left- and right-screen presentation lists are generated. The position number of each image is indicated between the left- and right-screen presentation lists. Several functions are available when working with the presentation order. Using the appropriate button, the user can insert a blank screen, duplicate or delete an image, and reorder the list. The user may also work with the left- and right-screen presentation lists in thumbnail view by clicking the *View Thumbnails* button in the Selection Review window (see Figure 9). From this view, the user can see the comparison of the images when projected. The user can duplicate, delete, or reorder the list by clicking and dragging the thumbnail, and move images between left and right screens by dragging thumbnails. As the user moves the cursor over an image, its title will appear at the top of its respective list. Closing this window will bring the user back to the Selection Review window.

Once the left- and right-screen presentation lists have been built, they can be saved in two different formats: ProjectImage and HTML. Saving the lists in ProjectImage format allows the user to display the selected images in an appropriately equipped classroom. The HTML format file that ISIS generates includes thumbnail images along with the following data fields: *Artist, Primary Medium, Secondary Medium, Date of Start, Date of Completion, Credits*, and *Accession Number.* Clicking the thumbnail displays the full-size version of the image. The HTML format can be uploaded to a class Web page for students to access outside of class.

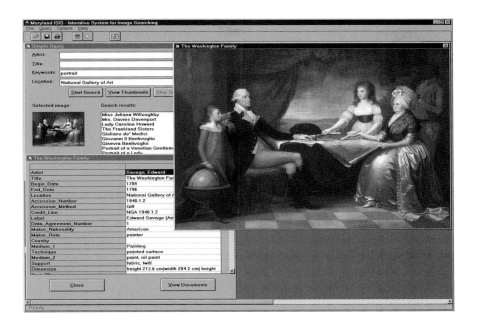

► **FIGURE 8** Basic information and full-size images are readily available

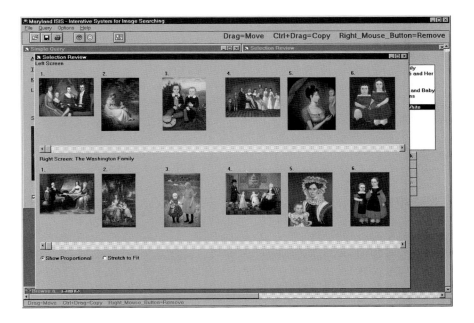

► **FIGURE 9** Ordering the presentation using thumbnail view

ProjectImage

ProjectImage provides the ability to display the lists of images generated in ISIS. An electronic classroom supporting two projection screens and two instructor computers is required. After launching the ProjectImage left- and right-screen programs and the

ProjectImage control program, the user loads the list of images. The images in position 1 are loaded and control buttons are made available. The user may forward or reverse through the images either individually (left and right screen independently) or jointly (left and right screen simultaneously). As the images are loaded, a preview of the upcoming image is provided in the Control window (see Figure 10). The user also has the ability to "blank" the screen by clicking the light bulb button.

▶ **FIGURE 10** Control window of ProjectImage program

▶ Future Development

Further refinements to ISIS continue to be made. Although the MESL project has concluded, the Maryland MESL project team continues to collaborate. More faculty are being encouraged to use the software, and the Teaching Technologies staff welcomes their suggestions for improvements. Current efforts are under way to determine the best solution for delivering the functionality of ISIS via the World Wide Web. As with the development of the Windows-based ISIS, the development of the Web tool will involve collaboration and feedback between the primary users and the technical development team. The collaborative model at the University of Maryland established through the MESL project is being followed in new projects on campus involving the use of digital images in the classroom.

▶ Conclusion

The iterative process based on the collaboration used in the development of ISIS had many positive outcomes. A useful and robust software tool was developed that illustrates the wisdom of involving the primary users from the beginning of the development process rather than at the end. Faculty previously wary of technology were given the chance to contribute to the creation of a tool that would meet their needs—a process that dissolved barriers and fears that had previously seemed insurmountable. As the technological possibilities became clearer to the faculty, their pedagogical goals expanded. Faculty moved beyond

simply recreating the traditional system for teaching art history in a digital format; they explored ways in which technology could serve as a tool to facilitate cooperative learning, broaden communication in the classroom, and pursue experimental projects. Content specialists saw modes for organizing visual information that differed from the traditional methods of slide libraries. The emphasis on exchange early in the collaboration resulted in a discovery process for all members of the Maryland MESL project team. The relationships established between various units within the University community will continue to benefit future projects.

.·.

Evolutionary Progress : MESL's Impact at American University

KATHE HICKS ALBRECHT

► Introduction

Undoubtedly, the Museum Educational Site Licensing Project (MESL) has had a profound impact on each of the participating museums and universities. During the project, museums have either initiated or greatly expanded their electronic infrastructures and have adapted rapidly to the role of digital information providers. The university communities have grappled with using the vast array of educational materials, and faculty have begun to rethink teaching methodologies. The MESL participants will evaluate the project and share the results with the greater cultural community, thereby helping other museums and academic institutions build on the MESL model in developing their own digital initiatives. Examination of both the shortcomings and the highlights of the MESL project are important aspects of this evaluation process.

In the following pages, I will describe MESL's impact on the American University (AU) campus—in particular, how it has affected the art history classroom and slide library. I will share some insights concerning museum and university partnerships and the practicalities of migration from analog to digital media. In addition, the project's broad implications in relation to copyright issues and recent governmental initiatives such as the Conference on Fair Use (CONFU) will be discussed.[1] The controversial imbroglio over copyright in the digital arena, which has emerged concurrently with the MESL project, provides a distinct backdrop for the issues. Although the MESL project's legacy has yet to be fully understood, it is clear that the MESL project will affect future initiatives, such as the Art Museum Image Consortium (AMICO)[2] and the Museum Digital Licensing Collective (MDLC),[3] and that the ongoing dialogue will be enriched by the experiences of the MESL participants.

► The American University Art Department and Slide Library

In order to assess the repercussions of the MESL project on the American University campus and the art department, it is important to understand the existing infrastructure. The American University slide library is housed in the art department of the College of Arts and Sciences and supports departmental instruction in the fine arts and the history of art. The department, with a typical enrollment of 100 undergraduate majors and 50 graduate students, offers bachelor's degrees in studio art, design, and art history, as well as master's degrees in studio art and art history. American University's location in the nation's capital has enabled the art department to establish important working relationships with the greater cultural community. Students participate in museum internships, gallery visits, and research opportunities and begin to forge professional networks. Within the art

department, the slide library is used by a faculty of 14 full-time art/art history instructors and 15 to 20 temporary instructors. The latter may be curators from museums in Washington, D.C., distinguished faculty from other academic institutions, or local independent scholars. Art department curricula, in addition to servicing art and art history majors, form a fundamental component of the university's general education program. Non-majors must complete core courses in fine arts and art history as part of the requirement of a liberal arts education. In addition, many faculty members outside the art history discipline are beginning to use visual images as a classroom tool, and the slide library periodically provides materials for classes in history, literature, foreign language studies, philosophy, and education. Use of the visual image as a tool for the humanities classroom is an emerging trend on the AU campus, which is reflected on other campuses nationwide.

The slide library houses a collection of more than 100,000 35 mm slide images of significant works of architecture, sculpture, painting, and photography, as well as examples of the minor arts[4] and graphic arts.[5] Performance art, site installations, and earthworks have recently been added to the collection. Although the slide library collection has a western European foundation, it also contains many fine examples of Asian, Native American, and African works. There is a strong representation of women artists throughout the collection.

The slide library is managed by a full-time curator who develops and maintains the collection and supervises the work of art history graduate fellows. Under the curator's guidance, more than 2,000 new slides are cataloged and labeled each year. Although plans are under way to automate the records management system, no records have been placed in the computer, and labeling is done on an electronic typewriter. At the outset of the MESL project, there were two stand-alone computers in the slide library: old, outdated PCs used mainly for word processing by the slide library staff.

Before becoming involved in the MESL project, the art department was almost technology-free. Although fiber-optic cable was being installed elsewhere on campus, the art building was placed last on the list for network installation as a result of the art department's lack of interest in new technology. No member of the art department had expressed a desire to use networked information, so no complaints were lodged about the lack of fiber-optic access in the building. AU art historians continued to conduct traditional slide lectures in darkened classrooms, displaying an average of 50 to 100 personally selected paired slides during each discourse on art, culture, and history. The 35 mm slide image was the backbone of the art history lecture, serving as both memory tool and object of study.

▶ The MESL Project Is Introduced on Campus

In recent years, many professional visual resources curators had begun electronic initiatives incorporating digital images. The development of software such as Adobe Photoshop, Thumbs Up, and VRMS enabled visual resources curators to catalog and store digital text and images. This experimentation with new technologies was occurring in both academic and museum settings, and visual resources curators, historically responsible for maintaining Leica projectors and Kodak carousels, were thrown into the technology maelstrom. Activity and interest increased as word spread about the viability of various new media software, hardware, or peripheral configurations. In October 1994, the MESL project had issued a call for university participation. Inclusion in the project would certainly afford American University an excellent opportunity to begin experimenting with technology in the art department and elsewhere on campus. I had hoped to interest art history faculty in requesting computers and software to automate the slide library records. Perhaps participation in the project would provide the much-needed impetus to begin our migration

to electronic technology. News about our acceptance in the project elicited both excitement and apprehension among the newly formed AU MESL team.

The first MESL planning meeting was held in February 1995, at the Smithsonian Institution in Washington, D.C. The meeting gave participants the opportunity to meet and plan the long-term goals of the project and to prepare for the initial distribution of data. AU representatives who attended the meeting included myself, Visual Resources Curator; Diana Vogelsong, Assistant University Librarian for Information Services and AU MESL project manager; and Greg Welsh, Director of Academic Computing. Together we would form the MESL management team on campus.

At the first meeting, it became clear that the project was both complex and ambitious and that salient issues needed immediate resolution. Members of the seemingly disparate communities of museums, information technology, and academia came to the table at odds about these issues. Although we shared goals and certain values, our institutions' missions were varied, and we would need to work through our dramatically different perspectives. Would it be possible to do so? I sensed the greatest tension between the museums and academia. Although the network specialists needed an occasional reminder to focus on content, not form (or distribution), they were able to visualize and understand both museum and academic concerns. Museum/academic concerns hinged on the following factors:

1. *Use:* Museums were concerned that participating universities might use MESL images inappropriately. Would they want to use images on fundraising posters, advertising, and other promotional or commercial ventures?

2. *Security:* Museums were concerned that universities might not be able to provide adequate security for museum materials. How would universities prevent images from being released on the Internet and distributed worldwide?

3. *Education (rights management):* Museums felt that universities should educate their communities on the proper use of the project information, but that they might be unwilling or unable to do so.

As the MESL participants were assigned to working groups, there was lively discourse on the above issues throughout the breakout sessions. I was perplexed by the museum concerns. I knew that MESL use on our campus would be strictly educational, that we were planning to instruct students on the proper usage of MESL data, and that we would respect museum requests concerning security. Fortunately, after much discussion, project members came to an understanding of others' concerns about the issues, and the MESL Cooperative Agreement was drafted for use of the museum materials.[6]

Participants realized that we shared the same goals for the project and were not working from conflicting motivations. I believe that the cohesion that occurred during the first meeting was a large factor in the eventual success of the project. Participants suspended natural hesitations and concerns for the sake of this monumental experiment.

In light of the fact that we were just beginning to implement new technologies on campus, the AU MESL team decided to approach the project as a series of steps. The first step, the biggest, would be to mount the information onto the campus server and design a Web site for the data. Next we would conduct a series of faculty and student workshops to familiarize and train interested AU community users. Finally, we would offer classroom assistance to targeted faculty who had used images in the past. The new MESL coalition among the University Library, the University Computing Center, and the College of Arts and Sciences made this approach possible.

Greg Welsh, director of Academic Computing, and Terry Fernandez, manager of the New Media Center, coordinated the technological implementation of the project. Various options for delivering the materials were discussed at length. Digital jukeboxes and other

stand-alone options were considered. A series of CDs could be housed in the University Library and loaned out to interested faculty for use in their courses. It was decided, however, that it was important to reach the broadest audience possible and that ease of access would facilitate experimental use. A Web-based delivery system accessed through Eaglenet, the American University fiber-optic local area network, was selected. During the summer of 1995, Terry and two computer sciences graduate fellows worked for several weeks to mount the images onto the campus server. An art department graphic arts graduate consulted on the design elements of the site. A Macintosh workgroup server (model 8150) with 80 megabytes of memory stores the information and allows access for up to 50 users at a time. Access is restricted to accounts with American University Internet addresses. In consultation with the AU MESL team, the New Media Center Manager supervised the original Web site design and continues to monitor updates of the material and refinements of the Web site.

Diana Vogelsong involved library faculty in the project and they, in turn, began introducing MESL to students, faculty, and other users. Reference classes added a section on the project, and the database was linked to the University Library's Web site. The library acquired a high-end Power Macintosh workstation for its Media Services Department that was dedicated to the MESL project. Students could access the information and receive assistance from trained staff members.

As a representative of the art department and the College of Arts and Sciences, I served as a liaison to instructors interested in working with the networked images. Faculty from the literature department, the School of Communication, the history department, and others who had borrowed images from the slide library were called about the MESL project. These "cold calls" introduced faculty to the project and explained the access method. MESL team members made broad recommendations about possible uses and projects and offered support and assistance in implementation. Input on content selection was solicited for future distributions.[7] In addition to the faculty calls and selection requests, the MESL team conducted several workshops during that first year, both hands-on and informational sessions, to continue the campus-wide familiarization process. The team demonstrated teaching applications, using various presentation software packages and digital projector equipment. As word spread, more and more faculty, staff, and students began to visit the Web site. Several thousand hits per month have been regularly recorded since those first months of the project.

During the MESL project's first year, we found that course use was sporadic. The database did not become available for viewing until several weeks after the beginning of the fall semester, so during that semester only one art historian used the materials in her courses. In the spring, other art historians began to recommend the MESL database as a source for research. Students in Pat Meilman's "Renaissance Art" course used the images to select specific works of art from the collection at the National Gallery of Art as term paper topics. Once they made the selection online, students visited the Gallery and conducted visual analyses of the paintings. In some cases, curatorial documents were linked to the MESL images and provided additional research material for the students. Meilman felt that her students used the MESL database to their advantage throughout that first year, and several students thanked me personally for making the works available online.

▶ Implementation on the American University Campus

By the fall of 1996, as the project entered its second year, evolutionary changes had altered the art department and slide library. In addition to the MESL project, several other digital

initiatives were being developed, and these piggybacked neatly with the larger project. Three new computers had been purchased during the summer, all connected to the university's fiber-optic network. Our status on campus as "MESLites" had shifted the art building to high priority for network installation, and we were connected to the fiber-optic network in September 1995. In the slide library, one new PC served as administrative workstation for word processing, e-mail communication, and Internet access. A powerful stand-alone work-station was used exclusively for image scanning. That computer supported a Zip drive and slide scanner as peripherals. Adobe Photoshop was purchased to process digital image infor-mation. In addition, a new laptop and portable digital projector were purchased for use in classroom presentations. Since its purchase, the projector/laptop has been used regularly in demonstrations of the MESL project and other electronic art history resources.

As visual resources curator, I conducted several classroom tutorials during the MESL project's second year. These helped to pique the interest of both art history faculty and stu-dents. Tutorials were provided for two sections of "Modern Art," a course on "Creativity and Computers," and a "Museum Studies" course for the Washington Semester program.[8] Each session provided students with course-specific electronic resource information, includ-ing an overview of available research materials, a demonstration of the MESL database, and basic access and search information. In addition, I reviewed issues of digital intellectual property rights and educational fair use, proper usage of networked information, and elec-tronic citation formats. After tutorial instruction, both students and faculty eagerly began using the MESL database and other Web sites for information on art and artists.

Other departments also experimented with MESL use during the project's second year. The School of Communication used the MESL database in two courses, "Visual Literacy" and "Basic Digital Imaging." In the latter, students were provided with an overview of dig-ital imaging technology through lectures, guest speakers, and hands-on computer training. Students learned the basic aesthetic, ethical, and technical aspects of digital imaging. The MESL database was used as the primary resource for final student projects, the develop-ment of "Virtual Exhibition" posters. For these projects, each student used elements from at least two MESL images to create a poster montage for a proposed museum exhibition. Theme, title, and a brief exhibition description accompanied each poster.

During the second year of implementation it became clear that our participation in the MESL project had enabled us to shift from exclusive reliance on the traditional educa-tional tools of slide lecture and support text to a mix of lecture, text, and fluid electronic tools for study beyond the classroom. We learned how time-consuming and complicated those simple changes were and realized that a move to daily classroom projection of digital images would require costly infrastructure changes. The portable digital projector, though suitable for periodic classroom demonstrations, would need to be replaced by a paired, fixed, high-resolution digital system. Although university administration has begun out-fitting electronic classrooms, the prohibitively high costs must be overcome before full-scale migration to the electronic classroom is feasible.

▶ Ongoing MESL Impact on the Art Department and the American University Campus

The art department has changed dramatically over the course of the MESL project. We are recognized on campus as a department whose groundbreaking applications of elec-tronic technology in the teaching/learning dynamic are noteworthy. There is genuine inter-est in electronic research and study among the art history faculty, and funding has been forthcoming for various digital projects. In today's academic environment, in which

programs are constantly cut, re-examined, and folded into other programs, the importance of the department's MESL project involvement is significant. The project has given us a renewed sense of mission, and we realize we can contribute to the development of new teaching methodologies using advanced technological tools.

A new and dynamic coalition of library, computer sciences, and art department staffs has emerged on campus. Together we have successfully managed the MESL project, and we foresee remaining partners on other initiatives. Limited-access course Web pages are being developed for student study, art history reference tutorials are now conducted by network specialists in the library, and future avenues of cooperation are being sought.

There is also an enhanced connection between student, work of art, and museum. The preexisting relationship between Washington, D.C. museums and the American University has been strengthened, and AU students are inspired to visit local museums and pursue a deeper knowledge of their own cultural heritage. The fear that easy and prolonged access to the visual surrogate would keep students away from museums seems unfounded. Indeed, students may be more likely to visit museums whose holdings include the original artworks with which they have become intimately familiar in digital surrogate form.

► Lessons Learned : MESL Insights

During the MESL project, the participants discovered insights concerning educational use of networked information. Our hands-on experience with the MESL database has allowed us to make pertinent observations about project use and practicality and has given us new views of the future of technology on campus.

We learned that it is impractical to think of a university "site" as a physical location because new technologies have expanded the university beyond the traditional grassy quadrangle and four-walled classroom. Distance learning is becoming an important part of course offerings, and students today need and expect remote access to course materials. Information providers must consider this when developing site licenses (perhaps more correctly termed institutional licenses), and permit access through university affiliation as opposed to physical on-campus presence.

University participants learned that students exhibit different levels of technological proficiency. Even today, many new freshmen arrive on campus without a personal computer and with little previous experience with networked information. Those students have no access to computers outside crowded university labs; others, who live off-campus, may not have online access from home. Factors such as socioeconomic status, gender, and career interests may affect a student's technological capabilities. These disparities may dissolve over the next several years, but until they do, these factors must be considered when developing curriculum equally accessible to all students.

One encouraging insight, alluded to already, is that all students, despite their varied levels of proficiency, seem eager to embrace technology as it is being applied in the classroom. Some experts have argued that easy access to digital copies of original art images may jeopardize the underlying value of the original. Karen Akiyama of Corbis Corporation stated recently that for "fine art . . . mass distribution diminishes the intrinsic value of the work . . . controlled access and distribution actually safeguard the economic value of these works."[9] I contend that the MESL project demonstrates the opposite. Heightened student interest in viewing the original works of art after experiencing the digital version ultimately raises the value of the original; consequently, the museum housing the original object enjoys increased stature and wider public interest.

▶ Lessons Learned : MESL Barriers

Despite the fact that the project achieved much of what it set out to accomplish, barriers to learning were discovered along the way. As outlined below, problems with selection, distribution, faculty support, and necessary curriculum adjustments were stumbling blocks to implementation. Although none of these proved insurmountable, they are factors that should be considered when establishing future initiatives.

In the early stages of the project, participants quickly learned that image selection was time-consuming and cumbersome. Faculty members knew the types of art images they needed, but were not necessarily familiar with specific museum collections. Museums had some images already digitized and wanted to share those, but were less willing to scan new works for the project because of the costs involved. Matching needs to availability during the first year's selection process took several weeks. The second-year content selection Web site was a vast improvement, but was still too cumbersome to be practical in the long term.

We quickly learned that the process of data distribution was also more costly and time-consuming than originally anticipated. Our bold assumption that data could be delivered quarterly was clearly infeasible. We resorted to once-yearly distributions, and even those were difficult to orchestrate. There were data corruption problems, difficulties with non-standardized information from different museums, and other technical problems. At AU, we owe a debt of gratitude to Terry Fernandez and her assistants, who were eventually able to iron out all the technical glitches. Future networked information initiatives would need to address standards issues in order to enable smoother distributions on campuses.

A major barrier for art historians was that the MESL images did not provide enough breadth or depth of materials to support teaching entire courses. In all cases, MESL images had to be augmented with images from the existing slide collection on campus. Until a critical mass of images is available, networked cultural information will not replace the slide repositories at universities.

We found, also, that faculty members need incentives to develop curriculum to accommodate the digital materials. Adjusting curricula to fit available images, manipulating the digital data, and learning to use electronic hardware took more time than is commonly available in an educator's daily routine. Sally Promey, Art History Professor at the University of Maryland, estimates that she spent 200 pre-class hours developing her MESL-based course. Some MESL universities, including American University, were not able to support MESL faculty through course release time or financial incentives, so many instructors could not incorporate the images into their courses. Partially as a result of this problem, institutions were not able to demonstrate "normal usage" of the information, nor to enable value-added university information to flow back to the museums, both of which were project goals that remained unrealized. Adapting curricula, changing habits, accommodating a steep learning curve, and lack of financial support were all factors that forced deadlines to be extended and project refinements to be abandoned. For example, although member institutions were given permission to use reference tools such as *Art & Architecture Thesaurus* (AAT), *Union List of Artist Names* (ULAN), and the *Getty Thesaurus of Geographic Names* (TGN),[10] at American University we were unable to do so because of limited external staffing support.

▶ MESL and the Concurrent CONFU Dialogue

The MESL project unfolded concurrently with the Clinton administration's effort to update the Copyright Law of 1976 to account for digital information. This was part of a

larger administration goal to develop "comprehensive telecommunications and information policies and programs that will promote the development of the NII [National Information Infrastructure] and best meet the country's needs."[11] In the summer of 1994, a preliminary draft report (Green Paper) entitled *Intellectual Property and the National Information Infrastructure* was released by the Intellectual Property Working Group of the Clinton NII task force, chaired by Bruce A. Lehman, Assistant Secretary of Commerce and Commissioner of Patents and Trademarks. After the Green Paper's release, there was broad public dissent about its content. A large segment of the population, including many library associations, academic institutions, and nonprofit groups, felt that educational fair use as an aspect of American copyright law was being minimized or undermined by the Green Paper's interpretation for digital media. As a result of this public outcry, the Department of Commerce convened the Conference on Fair Use (CONFU) in September 1994 to study the issue of fair use of digital information. The IPR Working Group's final report (White Paper) was released in September 1995.[12] The final report on CONFU proceedings was due out soon after CONFU's final meeting on May 18, 1997.[13]

Early in 1996, I became involved in the CONFU process as a Visual Resources Association (VRA)[14] representative to the Digital Images Working Group, one of five created by CONFU to address specific aspects of educational fair use.[15] The Digital Images group met monthly and worked to draft a set of guidelines for the academic use of digital images. This was of particular concern to slide collection curators who anticipate the eventual migration to digital media and who need to continue to support the needs of their educational clientele during this transition. Participants from a variety of associations were asked to attend the meetings in an attempt to broaden the representation on both sides of the issues.[16]

At the first CONFU meeting I attended, I discovered that the fears of the content providers echoed closely the original fears expressed by the MESL museums. The content providers at CONFU, in this case representatives of both museums and publishers, feared that universities wanted access to their properties for publication or commercial remuneration. They worried that universities did not have a clear understanding of intellectual property rights and that little or no effort would be made to instruct users (students, faculty, staff) in proper and improper usage. As a MESL participant, I had seen consensus reached over similar issues. A familiar dialogue began in earnest at the CONFU meetings. Those representing academia explained that universities did not want to grab market share from publishers, that academia's goals were not commercial. We reassured rights holders that we understood that it was necessary to seek permission to use images in commercial publication, both electronic and print. We informed publishers and museum representatives that universities can and do implement controls to protect and secure intellectual property. We described the success of the MESL project's realm control through Internet addresses[17] and discussed other mechanisms to restrict access, such as password/ID control. We described the MESL on-screen notifications and disclaimers. At the same time, universities involved in CONFU insisted, as we had at the MESL meeting, that students should be allowed to print copies of information for course-related use and that image manipulation should be permitted as part of a student's creative work.

The MESL project originally intended to produce a model site license for academic use of networked museum information. The CONFU working group originally intended to develop widely acceptable guidelines for the educational use of digital images. Neither group accomplished those goals. That being said, the two projects made a great deal of headway. Both the MESL project and CONFU began and moderated a national dialogue on educational fair use of networked information. Both projects brought diverse communities together to discuss mutual concerns. Museum curators and academic faculty, information technologists, publishers, and librarians met and learned from each other, and

parted with an appreciation of both their common interests and the other's divergent needs. As stated earlier, the MESL project has emerged as an important pilot project, spawning new partnerships and ambitious initiatives such as AMICO and the MDLC. The MESL participants, under the guidance of Mary Levering of the U.S. Copyright Office and Melissa Levine of the Library of Congress, developed an extremely useful document on terms and conditions for the academic use of networked museum information.[18] This document, gleaned from the practical experiences of the MESL project participants and infused with CONFU sensibilities, is an important first step. CONFU has come to an end, but various participants will continue to meet.[19] Although the Digital Images Guidelines were not endorsed by the majority of participating institutions, they may be tested over the next year by some of the institutions that did endorse them.[20] This testing period will reveal the guidelines' usability, weaknesses, and strengths. Other institutions that did not endorse the guidelines may work to develop their own guidelines or principles, using CONFU as a starting point.[21] Coming to terms with the dichotomy between the rights of the creator/rights holder and the right of the public to access information for educational purposes will be an evolutionary process, not a revolutionary one. CONFU and the MESL project are both important steps in that evolution.

▶ Beyond the MESL Project

Technological advances in digital imaging and network capabilities will change the scope of the classroom. It is inspiring to contemplate digitized images projected in class, electronic study guides and online syllabi, and universal access to worldwide networked data collections. The MESL legacy is clear. The project has made these changes not just a dream, but a possibility. The MESL project has paved the way for other initiatives to build on a model in which museums provide significant cultural information via electronic networks to educational institutions for teaching, research, and study. We have seen that those educational institutions can monitor and secure the information in a way that is acceptable to museums and yet is flexible enough for varied use on campus. We have observed teaching methodologies begin to evolve given enough university support and sufficient fiber-optic infrastructures. We have learned that new coalitions can be forged between purveyors and users of cultural information. To facilitate this cultural evolution, interested parties must support faculty as they experiment with new technology and must continue the dialogue on digital intellectual property rights with those on all sides of the issues. We must refine the models for licensing, with the understanding that educational access to cultural information is imperative and that educational fair use must be taken into account.

▶ Notes

1. CONFU was convened by the Department of Commerce in 1994 to address the issue of educational fair use in the digital environment.
2. The Art Museum Image Consortium (AMICO) was founded in 1997 by the Association of Art Museum Directors (AAMD). The members of this not-for-profit organization "will build a shared library of digital documentation of their collections for licensing and distribution to the educational community." At the December 1996 MESL meeting in Santa Monica, Maxwell Anderson, AMICO project director of the Art Museum Network and Liaison for Information Technology, AAMD, noted a desire on the part of AMICO to build on the MESL operating model.

3. The Museum Digital Licensing Collective is a national initiative sponsored by the American Association of Museums. The Collective proposes to make museum materials available to academic institutions and other nonprofit entities, in addition to implementing a for-profit division.

4. The minor arts in the AU collection include ceramics, ivories, enamels, glass, mosaics, metals, textiles, and many fine examples of interior furnishings.

5. Graphic arts consists of prints and engravings, drawings, manuscripts, and contemporary textual art.

6. Visit the MESL Web site at *http://www.gii.getty.edu/mesl/about/docs/agreement.html* to view the Cooperative Agreement in its entirety. The Cooperative Agreement also appears as Appendix B in *Delivering Digital Images: Cultural Heritage Resources for Education* (Los Angeles: The Getty Information Institute, 1998): 166–170.

7. First-year content selection occurred during the spring semester of 1995. Faculty spent hours selecting desired works from the museums' long lists of potential choices. This process, although time-consuming, resulted in a diverse offering of images that first year. The following year we introduced an online selection process.

8. The Washington Semester program is an AU exchange program. Students from other universities spend a semester in Washington in concentrated study in their chosen field. In the Museum Studies course, students attend lectures by museum curators, tour significant historic sites, learn about the Capitol and its environs, and study museum administration.

9. Karen Akiyama, "Rights and Responsibilities in the Digital Age," *Visual Resources, An International Journal of Documentation* 12, no. 3–4 (1997).

10. These are authority lists developed by the Getty Information Institute to facilitate automated retrieval of cultural materials. By defining and cross-referencing art and architectural terms (AAT), artists' names and variant names (ULAN), and geographical place names by hierarchical clusters (TGN), the Getty Information Institute provides new and enhanced levels of standards and resources for art history research.

11. U.S. Patent and Trademark Office, *Intellectual Property and the National Information Infrastructure: The Report of the Working Group on Intellectual Property Rights* (White Paper), introduction, page 1 (1995).

12. Information on the White Paper can be found at the Patent and Trade Office Web site at *http://www.uspto.gov/web/offices/com/doc/ipnii/index.html.*

13. CONFU documents and reports can be viewed at the PTO Web site at *http://www.uspto.gov/web/offices/dcom/olia/confu/* or at the NINCH Web site at *http://www-ninch.cni.org/news/confu_report.html.*

14. The Visual Resources Association is a nonprofit association established to further research and education in the field of visual resources and to promote cooperation among members of the profession. VRA membership includes slide and photograph curators, film and video librarians, media professionals, slide and microform producers, rights and reproduction officials, photographers, art historians, and others concerned with visual materials.

15. The five working groups consisted of Distance Learning, Electronic Reserves, Digital Images, Educational Multimedia, and Interlibrary Loan and Document Delivery.

16. Participants included, among others, representatives from the American Association of Museums, the Association of Art Museum Directors, the Association of American Publishers, the American Association of Media Photographers, the Visual Resources Association, and the College Art Association.

17. During the course of the project, no security breaches were reported.

18. Further information on the MESL Terms and Conditions can be found in *Delivering Digital Images: Cultural Heritage Resources for Education,* Part II.

19. A CONFU follow-up meeting took place at the Library of Congress on May 18, 1998, and the Distance Learning Working Group met on September 11, 1997 in Washington, D.C.

20. At the May 1997 CONFU meeting, the American Association of Museums (AAM) proposed a recommendation that its member institutions test the guidelines over the course of a one-year trial period. Visit the NINCH Web site at *http://www-ninch.cni.org/issues/copyright/fair_use_education/confu/digimaam.html* to view the AAM proposal in its entirety.

21. The Visual Resources Association and the College Art Association are two groups that have expressed interest in developing guidelines.

˙⁓

Altering the Culture and Identity of the Museum : The Risks and Benefits of Providing Networked Information

ROGER BRUCE

The Museum Educational Site Licensing Project (MESL) brought museums and universities together in an experiment that may foreshadow a radical change in the role that museums play in society. By commingling museum data and university instruction, both cultures glimpsed what happens when museum content becomes readily available on campus networks. The results were significant and will have an impact on the missions—and the traditional measures of success—of both museums and universities. What follows are my own preliminary musings on the likely effects on the internal culture of museums of digital imaging and electronic access to museum information. I rely on my own institution, the George Eastman House, for examples.

▶ Background Information

In its first half-century, George Eastman House (GEH) was the world's clearest expression of an emerging connoisseurship on behalf of photographic art. The career of our first curator/director, the late Beaumont Newhall, was a triumph of art education devoted to the construction of, as he put it, "a foundation by which the significance of photography as an aesthetic medium can be more fully grasped." He was famously successful, and today, thanks to his and other curatorial careers, photography is as likely as other media to appear in visual arts venues. George Eastman House played an important role in helping illustrate the evolving practice of this relatively new art form. However, the GEH collections are far more vast than its history of exhibitions might suggest, and the collections have a broader historical usefulness than merely as a history of photography modeled on the history of art.

As we are about to celebrate our fiftieth anniversary, we find ourselves confronting the implications of networked museum information within our MESL partnership. Our experiences during the MESL experiment have helped catalyze new interpretive goals for the George Eastman House: that is, placing photographic arts within a larger context of visual communication. GEH is significantly extending its interpretive scope—the tracing of photography and related media at work in history and in culture. This ambitious and inclusive undertaking will represent the whole of photographic practice as the medium has evolved, in both technical craft and personal expression.

In an age when archived photographic information is more and more a bulk commodity, we must remain mindful that historic meaning and significance are based on reference. Recent fashions in literary critical theory have emphasized the indeterminacy of text. If text is indeterminate, what about the photograph? Every image begs for context at least as much as the isolated word. Photography has always been narratively

poverty-stricken. Its paradox is to be an utterly specific trace of its subject, and at the same time, a wonderfully indistinct transformation of that subject. We can see the texture, every hair, the subtle modeling of light—but what's the story?

In the course of half a century of exhibiting and interpreting both photographic history as well as the aesthetic projects in photography, the George Eastman House has established and defined practices and procedures that have become increasingly intractable. Job descriptions, staffing structure, clients for photographic reproductions, and audiences depend on evolved methods for granting access to physical objects—in our case, these happened to be photographic prints. As it turns out, photography is particularly well suited to digital distribution. The dematerialization of this form of distribution raises critical questions about century-old archival traditions based on categorizing physical arrangements of the most fragile tissues and fugitive traces of the photochemical process.

Posing such questions in tradition-bound cultures is very difficult. Peter Lyman, the university librarian of the University of California at Berkeley, notes, "Stable communication processes are essential to institutional order and all professions are slow to risk their traditional sources of authority (which rest, among other things, upon claimed monopoly rights to authenticate information in their domain). Anthropology suggests that successful new technologies must reinforce the core values of a group. All cultures, ancient and modern, know how to 'break' tools that compromise their sense of order and authority."[1]

► Initial Changes Brought About by Sharing Digital Images

For my museum, seeing the consequences of sharing our images as networked cultural heritage information has helped expand our interpretive mission vis-à-vis photography and imaging: a melding of the applied disciplines of the history of technology, social history, aesthetic inquiry, and the use and contemplation of emerging photographic technologies. Our participation in the MESL project has been instrumental in awakening us to an enlarged educational responsibility that confronts any museum that submits its collections data to the "liquefying" effect of the Internet.

When we first contemplated joining the MESL project, some of us imagined grateful students and faculty feasting upon a rich mixture of image and text in support of the proper study of photography. But we were in for a few surprises. For example, our museum had provided insufficient descriptions for groups of related objects (lot-level descriptions) and few synoptic overviews of collections, making for a difficult-to-navigate body of images and text, organized by photographer. The campus browser of our text data was adrift in a sea of artist names and the vagaries of "title." The larger the collection provided online, the less navigable the data, owing largely to inadequate treatment of image content within the text material. All of us at the George Eastman House became increasingly aware that these text data are artifacts of a set of prejudices internal to our museum, bias that could be traced to an overarching remedial project of raising photography to the precincts of fine art—a kind of tacit institutional mission during our first half-century of operation. To put it more bluntly, our data generally represents the leanest art historical information, rather than being the result of a more demanding analysis of image content, subject matter, or—dare we hope—meaning. Although this may not relate directly to the recent demands of our MESL/university partners, the George Eastman House curatorial staff have recently mounted an ambitious associated-texts project to amend our catalog data—the kind of activity undertaken by an institution moving to increase its interdisciplinary appeal.

▶ Libraries Were Here First

Library science is several years ahead of museum practice in the creation of digital content and standards to make that content universal. In the steady progression from basic catalog information to abstracts to full-text representation of articles and larger works, libraries are pointing the way to the networked universal resource. Howard Besser, consultant to the MESL project and theorist on multimedia databases and the social effects of information, articulates the change found in the fundamental practice of libraries—a change that may predict some significant changes for the museum community as well:

> Libraries are becoming less important for the materials they collect or house, and more important for what kind of material they can obtain in response to user requests. This movement from collecting material "just in case" someone will need it, to one of developing relationships allowing the library to deliver material from elsewhere "just in time" to answer a user's needs, is a profound shift for the library as an institution. This shift to on-demand delivery of material from elsewhere is a direct result of the recent proliferation of digital networking in an environment where standards for description were already well established.
>
> Along with the changes to libraries as institutions have come changes to the roles of librarians. The proliferation of networked digital information is causing a shift of librarians from caretakers of physical collections to people who identify resources that exist in collections housed elsewhere. This is currently evident in most major research libraries, where librarians spend much of their time creating (World Wide Web-based) electronic pointers to resources on the Internet. Efforts like this are likely to greatly increase in the foreseeable future. As museums embrace networking and convert their information into digital form, we can expect to see similar sweeping changes both in the roles of museum employees and in how the public views cultural repositories.[2]

Much internal discussion about visual databases in museums concerns applications that are parallel to or extensions of predigital museum practices, and largely reflect predigital museum policies regarding ownership of intellectual property, the presumed institutional audience, and definitions of "publication." For example, digital museum object catalogs resemble the electronic card catalogs pioneered in library science. These visual databases are finding aids—research tools installed to speed up the initial review of museum objects by researchers and to reduce wear and tear of collection browsing. Digital tools came into the museum precisely because they were perceived as more efficient replacements for older tools that supported traditional institutional tasks, but as is often the case with a new tool, new capabilities can spawn new responsibilities and new expectations. The push and pull of compelling new opportunities and increasing expectations of audience, student, and scholar have the attention of our museum management, curators, and educators, and are some incentives behind the revisions of more than a few job descriptions. What happens as card catalogs become comprehensive abstracts, and as abstracts grow to include full text and image representation of holdings? And then, what are the consequences of linking these data with other relevant resources throughout the world? For us, these "what ifs" merely represent the vague, yet compelling, desire of customers for museum intellectual content. (My museum is very far from establishing a significant online visual resource.) But the pressure on museum archivists and librarians is increasing—witness the boom in appeals to funding agencies to support digital acquisition of museum content.

One consequence of inter-institutional exchange of collections information may be the increasing cross-disciplinary use of collections previously dedicated to a single discipline. The history of photography as treated by George Eastman House portrays photography as a fine arts discipline. However, the artifacts collected in support of that study may be academically redirected in response to increased interdisciplinary access brought about by networked museum information. Omnivorous postmodern scholarship goes wherever it wants. In the near future, our collections may as frequently support labor history, for example, as the history of artistic photography.

▶ Leading Questions

The transformational engine of electronic communication is obliging museums to question the idiom of "museum outreach." Are museums reaching out, or are audiences reaching in? Is networked information our tool for the control of and distribution of our information, or is it their tool (that is, the tool of the audience) for reaching in and extracting meaning from our collections, meaning we may never have suspected? Of course, it is both. Museum professionals are part of a system that comprises the established tasks of collection and preservation. A museum's authority is derived not only from the control of information, but also from the control of access to collections. In the past, the control of access to collections resulted from the need to preserve rare or fragile objects. Historically, therefore, privileged access to collections was a necessity, and the privileged knowledge thus derived was a salutary consequence of the imperatives to collect and preserve.

The mission of the established museum will probably remain stable because the best custodianship of fragile objects will still require the management of physical repositories of, and scholarship in, material culture. However, our ideas about access to collections, our methods of interpretation, and our attitudes toward intellectual property may change. Perhaps a good way to discover change in our midst is to look closely at the evolving attitudes of the audience and the users of museum information. Museums often regard computerization and networked information and large relational visual databases as *their* tools, but networked information is already in the hands of millions of potential museum customers. Just as the hammer and the bow and arrow extend the power of the human arm, so the networked computer extends the reach of legions of remote visitors. It is now a fact that many museums with Web sites have global audiences they may never physically meet. Browsers visit the museum and may capture significant museum content short of the immediate physical experience of collections and exhibitions. They are not passive—they may capture text, image, or sound to study it later or pass it along to others. These transactions are largely unregulated—millions of electronic visitors are pushing through the gates. This alters the environment in which museums function.

Museums will benefit from the increased attention now being given to overarching arts and humanities systems studies, venues for information-sharing among humanities disciplines, articulation of the needs of data standards, and political/social advocacy for computer-assisted teaching and scholarship (for example, the recent academic initiatives in SGML and the Z39.50 communications protocol).

It is clearly time to reconceptualize our understanding of what it means to provide access to research materials. We need a better grasp of the "meaning" residing in our collections. In addition, we have an increasing obligation to predict the useful intuitive links between our resources and those of other institutions around the world. In the fields of study served by George Eastman House (the history of photography, for example), our physical collections will remain paramount for research, but in other disciplines, electronic

representations of holdings may adequately serve as the final authoritative resource for a visiting (browsing) researcher.

Unlike neighborhood libraries, museums are not housing "expendable" resources. When they acquire an object, they expect to keep it permanently. Does the same hold true for digitized images and text? This is a central question, because the commitment to maintaining digital resources is a complex and demanding responsibility. Digital information must be constantly copied into new formats as technical standards change, and playback or reader technology must be kept up to date. Unlike physical archives, a 20- or 30-year lapse in proper management of electronic files could mean the irretrievable loss of data. New technical resources are making the financial and managerial health of museums more vital than ever. The failure to observe (even for a few years) a few fundamental data management procedures could have disastrous results. The very fluidity of electronic data may offer a hedge against such risk if consortia of museums and archives could be organized to watch out for one another, making certain to refresh the data of institutions deemed at risk. Of course, this kind of relationship predicts less and less autonomous authority for museums, which will need to view themselves as components in a larger, networked global matrix of authorities.

▶ Flowing Together Yet Regarded Apart

Museums and libraries support collective social memory. We have a responsibility to maintain a clear distinction between the chaotic jumble of the Internet and the aggregate expertise and scholarship accumulated over time in these historical repositories. Full participation in globally networked communications need not dilute or otherwise compromise that legacy. Museums may choose to generate earned income from the batch licensing of digital images—and if they do, they will need to offer a warranty on its accuracy. Curatorial professionals will be developing products in support of a global knowledge base—albeit tagged with his or her credentials and the imprimatur of his or her institution. While the relationship between individual curator and institutional collection will remain primary, it will be easier for curatorial research to range into the domains of other institutions around the world. For all of this to work for the advancement of knowledge, institutional openness and freedom of information exchange must be made to coexist with the tagging and referencing of institutional source.

Expressing and fulfilling their educational missions on the Net, the museum's curatorial texts are expanding beyond the exhibition and the exhibition catalog. Regardless of the delivery medium, museum output—the result of research, educational abstracts, or notices of recent acquisitions—can be posted as knowledge packets bearing the identity of the originating organization. The global sharing of museum data need not cause the loss of institutional identity. Museums can specifically target curricular needs of public schools and universities, offering everything from direct online access to catalog information to downloadable instructional materials for the classroom teacher. For the educator, scholar, or casual browser, the imprimatur of the museum resource should remain the seal of warranty.

Museums can enlarge their digital presence with judgment and expertise, adding a non-corporeal "value" to Internet content. Behind the computer firewall, in the museum's buildings, in its day-to-day management, as the sum of its curatorial practices, value accumulates in the form of contextualizing data—an accretion of transmissible intellectual assets. Although this value may exist only in the abstract (museum property but not museum object), this little abstraction is the "killer app." Far from "liquefying," the cultural core of the digital museum can remain solid. The museum's authority can remain firm

in its guaranteed testimony of provenance and citation of interpretive texts, all traceable to objects held in trust. There is a new potential in the machinery of networked cultural heritage information—the potential to adequately track and document the authenticity of the information, perhaps better than ever before.

▶ Notes

1. Peter Lyman, "Access Is the Killer App," in Proceedings of the 1995 Monterey Conference, *Higher Education and the NII: From Vision to Reality* (Washington, D.C.: EDUCOM, 1996): 9.
2. Howard Besser, "The Changing Role of Photographic Collections with the Advent of Digitization," *The Wired Museum: Emerging Technologies and Changing Paradigms,* ed. Katherine Jones-Garmil (Washington, D.C.: American Association of Museums, 1997).

◡⋅

Experiments at the Harvard Art Museums : MESL as a Catalyst for Change

MIRIAM STEWART

The Harvard University Art Museums signed on to the Museum Educational Site Licensing Project (MESL) almost simultaneously with the introduction of museum-wide access to its collections management database (which has been available to museum staff since 1994). Previously, most curatorial departments kept their own records in a variety of different ways—through catalog cards, notebooks, or curatorial files. The database allowed us to broaden our view of the collection as a whole: It became readily apparent that there were works by Paul Klee in three separate departments; in one department Claude Lorrain's works were found under "Claude," while in another they were classified under "Lorrain." As a result of these types of discoveries, discussion and coordination between curators was initiated. The power of the database to search on many levels transformed user access, enabling radical new search strategies.

The ability to link images to the database also suggested new ways to examine our collection. The possibility of having an image of a Greek lekythos, a Persian carpet, or a painting by Manet visible at the same time that the textual records appeared was tantalizing. We also began to contemplate using the images within the museum to select and arrange exhibitions or to document conservation treatments.

Three years ago, few of us would have dreamed that new technology would lead to opening our storerooms electronically. Participating in the MESL project necessitated sending images to the seven participating MESL universities, managing Web sites, and scanning original works of art. Suddenly our collection had become available to a much wider audience. But "easy" electronic access—to both images and documentation—raises its own questions and concerns, many of which we in the museum have wrestled with during the course of the MESL project.

▶ MESL Participation

Like the other participating museums, or "content providers," the Harvard Art Museums diligently tried to select works in our collection according to the desiderata of the teaching institutions. While every effort was made to accommodate specific requests, the urgency of the deadline for supplying images—about eight weeks—did not often allow us to provide works that had not been photographed in color. Ultimately the selection was based on those works for which we had existing high-quality color slides or transparencies—in most cases, those objects in the collection that were most often requested for reproduction. Therefore, although our MESL selection is very strong in nineteenth-century European paintings and drawings, for example, it does not reflect Harvard's comprehensive collection. Twentieth-century works with questionable copyrights were not included, thus further restricting the group. The limitations that we found ourselves working under proved frustrating for the

curatorial staff, in particular, since content selection was the one area in which most felt qualified to participate. The process also raised questions of priorities within our own institution—should images for the MESL project take precedence over those for our own internal projects?

▶ Scanning Experience

The Harvard Museums acquired a flatbed scanner in preparation for new database imaging capabilities at about the same time we joined the MESL project. We hoped to learn to create digitized images ourselves, because we didn't have the resources to send them out for digitization off-site. Images were scanned from color transparencies and slides by dedicated but inexperienced staff, students, and volunteers. It soon became apparent that scanning was more complicated than we expected. We discovered that black-and-white prints and color transparencies translated more faithfully than color slides, and that, unfortunately, given the tight MESL deadline, there was little time for color correction or for making new transparencies. The quality of the images of the some 500 works that Harvard contributed to the first round of the MESL project varied dramatically. It is clear now with hindsight that if we had had more time and experience we would have been better able to represent the museum and the works in our collection.

That said, we did learn valuable lessons about scanning and image management in general, and the many questions the process raised are still under discussion at the Harvard Art Museums and many other institutions. Are we aiming for simple recognition, or are we trying to record the artwork at the highest possible level? What kind of resolution best represents fidelity to the original work? How can we best store and retrieve image files of great size? Do we have the resources and expertise necessary to correct for color? And the perpetual question: Where and how will we find the time, money, and staff to support a digital imagebase?

▶ Image Documentation

In the context of a discussion on digitized images and the MESL project, it is essential to emphasize the importance of the documentation provided with each image. The museum's paper curatorial files often contain treasure troves of information about the works in the collection, including basic "tombstone" information and provenance, bibliography, exhibition history, and curatorial notes. The accumulation of decades of scholarly research on the objects can be crucial to an understanding of their history and significance. The gulf between the basic information in our database and the paper files can be enormous, although we have been able to make some progress in data entry and research through grants to verify our records. The MESL images with the most complete documentation reflect those collections within the museum where data entry is more advanced.

During the course of the MESL project, the Harvard Museums embarked on a number of digital imaging initiatives, which, while not directly related to the MESL project, enhanced our reserve of images that could be shared. The first flatbed scanner in the museum was installed in the Mongan Center for Prints, Drawings, and Photographs, and its accessibility encouraged two of the three departments to scan works directly and, more generally, focus on the opportunities afforded by electronic image transmission.

▶ John Singer Sargent Web Site

Harvard holds one of the largest and most significant collections of works by Sargent in the world, comprising over 400 drawings, 35 sketchbooks, 33 paintings, four sculptures, and even the artist's brushes, watercolor tubes, and palettes. Melinda Linderer, the Lynn and Philip A. Straus Intern in the Drawing Department, researched and developed *Sargent at Harvard (http://www.artmuseums.harvard.edu/sargent/archive.html)* (see Figure 1), a searchable database of digitized images and textual information (description, provenance, bibliography, and exhibition history). This exemplary Web site offers scholars, students, museum professionals and collectors, as well as the general public, an electronic tour of this significant body of Sargent's work, most of which has never been published. A keyword inquiry for charcoal drawings related to Sargent's Boston Public Library murals, for example, will retrieve 47 records. Patrons can also move from thumbnails to larger-scale digital reproductions. As an interactive tool for scholarly exchange, the Web site encourages visitors to comment. The site is updated periodically with additional images and entries reflecting new scholarship. Nearly 300 of the museum's Sargent images were included in the MESL image bank.

▶ **FIGURE 1** *Sargent at Harvard* Web site home page

The scanner's presence proved irresistible to Marjorie B. Cohn, Carl A. Weyerhaeuser Curator of Prints, who was inspired to scan a selection of original prints after having seen poor-quality scans of transparencies and slides. After conducting tests to ensure the safety of the works, she scanned directly from the prints themselves to produce high-quality digital reproductions. She was then able to juxtapose images and, using the computer as a giant magnifying glass, zoom in on fine details and switch back and forth from one area to another. This technique promises to aid print scholars in comparing different prints and

multiple impressions of the same print in ways that would have previously been very cumbersome, as well as potentially damaging to the originals.

► Cartes-de-Visite

Deborah Martin Kao, the Charles C. Cunningham Sr. Associate Curator of Photographs, is similarly using digital reproductions to organize a collection of 10,000 *cartes-de-visite* (CDVs), principally commercial portraits, cataloged by studio as well as sitter. Keyword menus, adapted from a standard developed by the Smithsonian's National Portrait Gallery, are divided into categories ranging from gender, age, and race to dress, studio props, and action. Conveniently, CDVs carry their own documentation in the form of inscriptions, studio marks, and owner stamps. After scanning, the digital versions of the CDVs were configured to show recto and verso on the same screen, a format that offers a distinct advantage to researchers. This project, according to Kao, increases "intelligent use of the collection while decreasing the handling of the objects."

► Ben Shahn Photographs

Finally, Harvard's Ben Shahn photographs—approximately 5,000 photographs and negatives—represent the artist's personal photographic archive from the 1930s to the 1960s. Electronic technology made it possible to scan both negatives and positives, as well as to invert the digitized negative image to display as a positive (see Figure 2). This process allows photography scholars in the museum and the academy to compare negatives with final prints and their many variants in the collection. In addition, the Shahn images and documentation can be printed to travel with curators as they organize exhibitions. These particular materials are destined for a Web site (based on the Sargent model), which will complement a major Shahn exhibition (1999) to be organized by Kao and Laura Katzman. About 100 Shahn photographs were included in the MESL image bank.

► Extending Web Access to Harvard Art Collections

Other digital imaging projects have been ongoing at the Harvard Art Museums. Harvard's Straus Center for Conservation, for example, has long been using digital imagery in pioneering projects, notably in the recent exhibition, *The Fire of Hephaistos: Large Classical Bronzes from North American Collections*, a brilliant collaboration between scholars and conservators who investigated the practice of ancient bronze foundries.[1] In addition, the Harvard Museums designed and installed in our Renaissance galleries an interactive kiosk that focuses on the technical examination of three early panel paintings.[2]

The projects discussed above may seem like pure digital alchemy, and we must be careful not to be transported solely by the technical magic. They are not intended to replace the experience of the works of art themselves, but to foster fresh perspectives and new access to our collections.

It can be difficult to shake the inevitable view of Harvard as an institution which is at times inaccessible to the public. However, the Harvard Art Museums' mission strongly mandates education beyond Harvard Yard. The Fogg has long had an unusual policy of

open access—to *anyone*, not just scholars or students—to our public study rooms and storage areas. We are engaged in active discussions with the Harvard Library about including our collection in text form, beginning with prints and photographs, on the library online catalog, which is available through Harvard University's Web site. While we are still exploring how best to share our database and images, it seems likely that our rich resources will be increasingly accessible through the World Wide Web.

When we joined the MESL initiative, we had scarcely 100 digital images; within two years we had nearly 14,000. The confluence of our database, the ability to scan images, and the MESL project has been as exhilarating and inspiring as it has been overwhelming and exhausting, raising many questions. But I think that I can safely say that the MESL project has allowed us to think about using digital imaging capabilities in new ways. The profusion of imaging projects around the museum are testimony to creative exploration of a new medium.

▶ **FIGURE 2** Scans from Ben Shahn's 35 mm negatives, juxtaposed with their digital positives

▶ Notes

This essay is an edited version of a talk presented at the College Art Association meeting, New York, February 12–15, 1997, in the session "Teaching with Digital Images: The MESL Project's Impact."

Parts of this essay appeared in Sally Promey and Miriam Stewart, "Digital Art History: A New Field for Collaboration," *American Art* 11, no. 2 (Summer 1997): 36.

1. Harvard University Art Museums, 1996, catalog by Carol C. Mattusch et al.

2. Interactive computer kiosk created by Ron Spronk and designed by Robin Marlowe, "Investigating the Renaissance: Examining Material Aspects of Three Early Netherlandish Paintings Using Digital Imaging Technology" (Harvard University Art Museums).

∿

Musings on the Museum Educational
Site Licensing Project

MELISSA SMITH LEVINE

In addressing issues associated with digitizing museum and library collections and making them available—whether broadly via the Internet as the Library of Congress's National Digital Library Program (NDLP) aspires to do or through more specific licensed arrangements as contemplated in the Museum Educational Site Licensing Project (MESL)—one confronts unique legal, business, and ultimately social issues. All of these issues force an examination of previous practices and assumptions in both museum and university communities, and by society at large. Many of the most constructive MESL discussions of "terms and conditions" entailed the careful dissection and examination of a broad range of presumptions about behavior, business and economic models, and institutional expectations and needs—not solely legal issues with which the other concerns are inextricably intertwined.

The struggle of the MESL participants with these issues brought into focus some analogous challenges faced by the NDLP. The MESL project provided a laboratory in which to examine these issues at a critical moment within the broader discussions about the intersection of copyright and fair use of electronic materials, whether through the Conference on Fair Use (CONFU) or World Intellectual Property Organization treaties on copyright. Site licensing seems to be a tool that could facilitate universities' trustworthy stewardship of museums' precious legacy—reserving to museums sufficient control over image quality and corresponding information with the ability to manage legal issues associated with copying and use of such material.

▶ Legal Issues : MESL's Impact on Licensing

The Library of Congress's offerings consist of unique American history collections, offered through the Library's home page *(http://lcweb.loc.gov/)* as "American Memory." The American Memory home page *(http://lcweb2.loc.gov/ammem/)* describes the NDLP as an "online resource compiled by the Library of Congress." The description continues:

> With the participation of other libraries and archives, the program provides a gateway to rich primary source materials relating to the history and cultural developments of the United States. In the coming years, the National Digital Library Program aims to digitize millions of the Library's unique American history collections and make them freely available to teachers, students, and the general public over the Internet. Special collections to be digitized include the documents, films, manuscripts, photographs, and sound recordings that tell the story of American history. The program is funded by congressional appropriations and private sector donations.

For the NDLP, the MESL experience was a prism to examine the concept of site licensing as a possible tool for managing a plethora of concerns associated with making

rights-protected material available on the Internet. At the most basic level, the MESL experience led to further discussions at the Library of Congress about the possibility of using site licensing as a tool to make material subject to copyright or other protection available via the Internet in cooperation with rights owners. My participation in the MESL project was encouraged by Carl Fleischhauer of the NDLP and Mary Levering of the U.S. Copyright Office in the hope that the NDLP's experience with site licensing would be of use to the MESL project and that MESL might inform our discussions at the Library about the possible use of site licensing in the near future.

Site licensing in and of itself is not a new concept; libraries have site licensed subscriptions from publishers of electronic materials for some time now. The NDLP utilized site licenses in its pilot program to assess the use and impact of providing American history materials in fixed media to 44 educational sites. This pilot project predated the explosion of routinely available public access to the Internet by a few years; thus it implemented distribution in an existing fixed medium. Dissemination on fixed media minimized concerns about subsequent copying, separation of images from their identifying information, or changes by users that might affect the integrity of images.

As a practical matter, many of the Library's collections selected for inclusion in the NDLP to date are in the public domain: that is, not subject to copyright protection. However, there are numerous collections and items within particular collections with substantial copyright or other rights issues. Often there is insufficient information about materials to make a conclusive statement about legal status. (This may be owed to the age of items and the erratic nature of available information about items in collections.) Many of the Library's important collections of sound recordings and film are subject to copyright protection and will continue to be protected for years to come. We will need to seek cooperative arrangements with rights owners to make items in these media available any time in the near future, particularly given the lack of clarity in the application of fair use to new media.

The purpose of an NDLP site licensing program would be to maximize the number of electronic items and collections that the NDLP, and American Memory in particular, would be able to make available to the educational community for nonprofit, educational uses while minimizing risks associated with copyright and other legal concerns. The NDLP is discussing the possibility of making items or collections with particularly challenging rights issues available without license fees to nonprofit, educational institutions at specific physical sites, such as schools, libraries, and universities. Such an arrangement, which could reach the entire American public through the educational institutions, is consistent with the philosophical underpinnings of fair use. The proposed NDLP site licensing program would ideally be a mutually beneficial relationship between the Library and schools, libraries, and universities in which the Library, through its NDLP, would make American Memory materials available for educational use at specified locations affiliated with those institutions. The terms and conditions of the relationship would be stated in a written license agreement between the parties.

Discussions at the Library of Congress focus on the idea of a site licensing program that would provide a practical framework for implementing NDLP's policy of respecting legal rights embodied in Library collections while facilitating the broadest possible access to the public. Site licensing might allow the dissemination of material that might otherwise be imprudent to disseminate for copyright or other rights reasons. When copyright is likely to exist and a copyright owner is unascertainable, site licensing would allow dissemination to the educational community in a manner that is likely to minimize subsequent copying. It will also allow the NDLP to maximize the number of items made available: Copyright owners who might be unlikely to grant permission to use items in a universally accessible

Web site will, it is hoped, be more willing to permit electronic dissemination where access is limited to physical locations affiliated with an educational institution. This arrangement would theoretically minimize the extent of subsequent copying, particularly for other than educational, noncommercial uses.

Site licensing can serve as a tool for responsibly managing the stewardship of intellectual property in the care of cultural institutions. (Cultural institutions are, in effect, stewards of intellectual property in the same way as they are responsible for their tangible collections. The stewardship of collections is a familiar concern for collecting institutions, but the idea as applied to the intellectual property inherent in physical collections is perhaps a newer twist of perspective.) As conceived here, site licensing can provide a positive acknowledgment of the shared vision of the rights and responsibilities of the Library, educators, students, and the private sector. Even an initially modest program will provide a model for digital libraries in an otherwise undefined area. If handled optimally, an NDLP site licensing program might provide an opportunity to promote the NDLP with the educational and publishing communities while maximizing service to Congress and the educational community at large, with particular focus on the interests of primary and secondary education. This effort would also allow the Library to experiment with the development of additional distribution methods, channels, and arrangements; the development of strategies that permit the dissemination of otherwise restricted materials; the promotion and facilitation of the Library's digitized primary source material; the possible establishment of a model for the Library and other digital library efforts; and the fostering of sustainability and growth of the NDLP.

The Library is examining a tiered approach that would permit exploration of technical and administrative options, as well as the extent of interest. This approach is based significantly on my experience with the MESL project. The results of each phase will inform the next, such as investigating the value and efficiency of contracting the administration of the program out to a third party in later phases. If the Library does proceed with this approach, in the early phases licensees would probably be limited to institutions (not individuals) via site-specific access. In later phases, we would evaluate the possibility of making licenses available to individuals in response to the research community's preference for access to protected materials from any location for authorized users.

► Some Business Matters

The NDLP's five-year program is funded through a combination of congressional appropriations and private-sector support. While the NDLP is sensitive to funding issues, the Library's digital efforts are not motivated by a desire to produce revenue or the expectation that it sustain itself through revenue-producing activities beyond traditional development efforts. As a practical matter, it seems unlikely, at least in the near future, that organizations electing to pursue digitizing efforts will obtain substantial revenue from the licensing of digital materials. Many museums participating in MESL hoped at the outset of the project to be able to derive a revenue stream from subsequent licensing efforts—even if only to obtain some cost recovery for the expense of producing and providing digital content. In many respects, it seems that members of the museum community in general hope that licensing digital content will be a savior for tight budgets. However, high hopes and low expectations are advisable for now.

Admittedly, these projects are complex and expensive. One of the fascinating outcomes of the MESL dialogue, however, is the transition that many museums experienced during

the project. Financial incentive as a motivating factor for digital efforts diminished as philosophical commitment to the critical value of such efforts grew with experience. The concept of the digital initiative evolved into something viewed as a critical element of the museums' missions, not solely as a possible revenue source—and in spite of the high need for investment. It was also encouraging for museum participants to experience the enthusiastic desire of university participants for the newly accessible museum resources available through the MESL project.

This enthusiasm was evident both in terms of the universities' animated embrace of the possible uses of museum images in academic settings and, perhaps more importantly, in the potential access to the wealth of intellectual capital represented by museum resources generally. University participants articulated an eagerness to have many images, wonderful search engines, and options for coherent contextualized bodies of images and information—at the lowest possible cost, and with full legal warranties provided by the museums to insulate universities from any liability for misuse. Therein lies the rub. Site licensing is a way to manage legal duties. Legal duties are often ultimately business matters as issues of risk allocation, which is essentially a financial affair.

So it seems all things tend to return to financial concerns. How can museums skirt some of the heady business concerns for just long enough to determine what a sustainable business model might look like? Museums are unlikely to receive sufficient revenue from such efforts in the near future to build or sustain these resources, even though they would like to satisfy the ideals articulated by the MESL university participants, and may even view these ideals as inherent to their institutional goals and missions. For the immediate future, large-scale projects that are essentially in the mode of a for-profit model are likely to involve significantly more complex financial and legal concerns than those that seek primarily to serve narrowly drawn educational purposes.

In order to learn enough to develop appropriate business models for the long-term possibilities, we must proceed now, leveraging the results of the MESL project and other developing licensing models. The difficulty of the MESL discussions regarding business models indicates that perhaps for the immediate future the most productive approach may be to try to put aside business issues and focus on the development of intermediary modes of operation that allow the product and its distribution (so to speak) to evolve. This will surely require some resourceful fundraising and budgeting, and perhaps those burdens will be shared by museums and those universities that see the value of having such resources available for their curriculum and teaching purposes.

One economic historian notes that despite all the enthusiasm for the possibilities of the Internet—from shared resources to telecommuting—we do not know yet entirely what works; "the temptation to look at the past to guide us in making predictions and policy recommendations should be resisted. Historical analogies often mislead as much as they instruct and in technological progress, where change is unpredictable, cumulative, and irreversible, the analogies are more dangerous than anywhere."[1] The problem is that the past is all we have on which to base our present decisions.

The length and complexity of conversations about presumedly legal issues were also evidence of the difficulty of separating legal from factual and business issues. In response to the dilemmas associated with the initial goal of producing a form license agreement, the group adopted an issue-oriented approach which articulated tensions between museums as "content providers" and universities as "content users" (noting the relative nature of these labels) in relation to contractual terms found in typical license agreements. The resulting document, included in *Delivering Digital Images: Cultural Heritage Resources for Education,* is an invaluable tool for any institution considering these matters (whether a museum, library, or university) and serves as a more flexible tool than a form agreement.

▶ Other Thoughts

One of the striking things about the MESL project was the self-awareness of the effort. There is currently quite a bit of rhetoric as to whether humankind is in the midst of a technological revolution or evolution. If the latter, business and legal models will develop over time as "a process of gradual, peaceful, progressive change and development, as in a social or economic structure," according to my trusty, still-in-paper-form *Webster's College Dictionary*. By contrast, a revolution would manifest itself as "a sudden, complete, or radical change in something (a social revolution caused by automation) . . . a procedure or course, as if in circuit, back to a starting point . . . a moving in a circular or curving course, as about a central point." By these definitions, the MESL effort does not seem to represent an "either/or" proposition, rather an evolution *and* a revolution. Despite all the self-awareness, we cannot predict where all of this will lead. Yet, we need to be Janus-like in our deliberations.

I mention this self-awareness aspect for two reasons. First, it seems unlikely that historical changes that stemmed from technological innovation were always accompanied by such a conscious effort to predict the path of societal impact and to shape it. I am not prepared to justify that statement here. I mention this, though, to note the inevitability of what might be called "mistakes" by some and as "moments for learning" by others. This applies to the academic practice of history, as well as to the broader concept of learning from experience to shape appropriate laws and policies for addressing the changing social expectations wrought by new technology—and to determining what business models will be successful.

The other interesting, though perhaps not conscious, effect of the MESL project was to unite people from a broad range of disciplines with a common commitment to learning. Librarians, information technology programmers and analysts, art historians, curators, even lawyers—shaped this effort. Effectively, the result was an interdisciplinary union of the arts and sciences which for so long have been, perhaps, artificially separated. Perhaps the MESL project could be viewed, with not-so-rose-colored lenses, as a metaphor for the possibilities of digital initiatives as a Renaissance-like reuniting of science and humanities. The inherent complexity of projects like the Library of Congress's NDLP is that they require a unique range of expertise in participating individuals—and the ability to communicate beyond field-specific terms of art (or computer jargon) to arrive at desirable ends. These projects present the need and opportunity for modern Renaissance women and men in the most traditional sense—people knowledgeable or proficient in multiple areas of study.

A comment made by Thomas Lyman—a medievalist at Emory University and one of my college art history professors—also came to mind as the MESL participants worked through issues of "terms and conditions," and as the group's outcome-oriented effort to prepare a form license agreement evolved into an issue-based approach. Dr. Lyman's observation was that the analytical process associated with the use of primary and secondary material in the study of art history is similar to the process of legal analysis. There is a coincidental creative method applied in both fields: In art history, primary information begins customarily with art, while in law, testimony or other firsthand, factual information serves as primary material. Primary material is the factual evidence that girds subsequent interpretation and conclusion regardless of relevant discipline. Secondary material takes the form of opinion and interpretation supported by the evidence embodied in the primary material and experience. Both disciplines require critical analytical skills, close observation, the extraction of parallels and distinctions, citation of references, and attention to detail in the context of a larger continuum.

Though these observations extend in many respects to the liberal arts and sciences generally, the study of art history may arguably provide rich groundwork for the ability to take a fresh but disciplined approach to problem solving. My participation in the MESL project was based primarily on my professional legal experience. Yet, ironically, it may be that the ability to address novel legal, policy, and business issues as addressed in the MESL project is as related to analytical tools learned in the study of art history as to formal legal experience. The MESL project underscored the idea that digital technology is ultimately not at all about computers; rather, it is about human minds that continue to create and solve problems, as well as the curiously human need to divine meaning from mere information in the form of knowledge, and occasionally, wisdom.

► Note

1. Joel Mokyr, "Are We Living in the Middle of an Industrial Revolution?," *Federal Reserve Bank of Kansas City Economic Review* (second quarter 1997): 31.

About the Contributors

KATHE HICKS ALBRECHT is the Visual Resources Curator for the Department of Art in the College of Arts and Sciences at American University. She maintains and develops the slide library and coordinates several digital initiatives on the American University campus.

ELLEN YU BORKOWSKI is the Coordinator of Instructional Technology and Support in the Teaching Technologies unit of Academic Information Technology Services at the University of Maryland. She provides instructional support for the Teaching Theaters by identifying and developing teaching and learning materials, training faculty, and serving as a liaison to special projects and committees that focus on technology in education.

ROGER BRUCE serves as Director of Museum Education for the George Eastman House in Rochester, New York, where his current interest is in developing projects that explore the ways that photography and imaging transform the cultures in which they thrive. He is also leading the development of an Interpretive Master Plan for his museum.

CATHERINE HAYS is the Coordinator of Digital Technology and Electronic Media and the Director of the Electronic Media Center for the College of Arts and Humanities at the University of Maryland. She works with faculty, staff, and students to use digital imagery and multimedia technologies for teaching, learning, research, and creative expression.

MELISSA SMITH LEVINE is the Legal Advisor to the Library of Congress's National Digital Library Program. Formerly with the Smithsonian Institution, she now provides legal review of Library collections for issues such as copyright management, publicity, and privacy prior to release on the Internet. She also works with library staff, the U.S. Copyright Office, and the Office of General Counsel on a wide range of legal, policy, and contractual matters relating to the Internet. Formerly, she was employed by the Smithsonian Institution.

LAURA L. MEIXNER is Chair of the Department of the History of Art at Cornell University. Her research specialization is the cross-cultural influence of French and American art. She regularly incorporates MESL images into the curricula of her lecture courses on nineteenth-century European and American art.

DAVID MILLMAN is the Manager of Information Systems, Research, and Development of the Academic Information Systems unit at Columbia University. He oversees Columbia's Web presence and is responsible for technical coordination of the digital library program.

SALLY M. PROMEY is Associate Professor of American Art at the University of Maryland. Her publications explore relationships between visual culture and religion in the United States. Promey served as the University of Maryland Coordinator for MESL and as the chair of the MESL Faculty Training and Support Working Group.

BENJAMIN C. RAY teaches in the Department of Religious Studies at the University of Virginia, where he holds the Daniels Family, NEH Distinguished Teaching Professorship. He has published a textbook on African religions and another book on the kingship

of Buganda. He is the Adjunct Curator of African Art at the Bayly Museum of the University of Virginia, where he curates annual exhibitions of African art.

MIRIAM STEWART is Assistant Curator of Drawings at the Harvard University Art Museums (HUAM). She was a member of the MESL team at HUAM, and presented a talk on teaching with digital images and the MESL project at the 1997 College Art Association meetings.

PATRICIA MCCLUNG and CHRISTIE STEPHENSON managed the MESL project for the Getty Information Institute.

Credits

The reproductions of the computer display screens in this volume were produced in Adobe Illustrator 6.0 to improve their clarity and legibility in the printing process. The images in the screen shots were derived from the highest quality digital files supplied by the MESL participating museums. They were resized, converted to halftones, and then imported into the Illustrator files. The images on pages 15 and 16, reproducing the images manipulated by students as part of their assignments, are resized versions of the actual screen resolution images.

The Netscape Navigator and Apple logos are used with special permission.

NETSCAPE:

> Portions © Netscape Communications Corporation, 1997. All Rights Reserved. Netscape, Netscape Navigator, and the Netscape N logo are registered trademarks of Netscape in the United States and other countries.

APPLE:

> System Software Mac OS 8.1 © 1983–1997 Apple Computer, Inc. All Rights Reserved. Apple® and the Apple logo are registered trademarks of Apple Computer, Inc.

COVER, BACKGROUND IMAGE:

> Johann Heinrich Ramberg, *The Exhibition of the Royal Academy in 1787*, engraved by Pietro Martini, 1787, © The British Museum. Negative from which the image was manipulated, © The Courtauld Institute.

COVER, INSET IMAGES:

> Carroll Beckwith (1852–1917), *Palazzo Barberini, Rome*, ca. 1910, oil on wood, 1974.69.6, © 1995 Smithsonian Institution; courtesy National Museum of American Art, transfer from S.I., Cooper-Hewitt Museum of Decorative Arts and Design.

> Albert Bierstadt (1830–1902), *Lake Lucerne,* 1858, oil on canvas, National Gallery of Art, Washington, D.C., 1990.50.1, gift of Richard M. Scaife and Margaret R. Battle, in honor of the 50th anniversary of the National Gallery of Art.

Elmer Bischoff (1916–1991), *Two Bathers,* 1960, oil on canvas, 1968.52.7, © 1995 Smithsonian Institution, courtesy National Museum of American Art, gift of S.C. Johnson & Son, Inc.

Sandro Botticelli (1444/1445–1510), *The Adoration of the Magi,* early 1480s, tempera and oil on panel, National Gallery of Art, Washington, D.C., Andrew W. Mellon Collection, 1937.1.22.

Thomas Wilmer Dewing (1851–1938), *Music,* ca. 1895, oil on canvas, 1929.6.32, © 1995 Smithsonian Institution; courtesy National Museum of American Art, gift of John Gellatly.

Thomas Wilmer Dewing (1851–1938), *A Reading,* 1897, oil on canvas, 1948.10.5, © 1995 Smithsonian Institution, courtesy National Museum of American Art, bequest of Henry Ward Ranger through the National Academy of Design.

George Inness (1825–1894), *Lake Albano, Sunset,* ca. 1874, oil on canvas, National Gallery of Art, Washington, D.C., 1962.2.1, gift of Alice Dodge in memory of her father, Henry Percival Dodge.

Lois Mailou Jones (born 1905), *Les Fetiches,* 1938, oil on linen, 1990.56, © 1995 Smithsonian Institution, courtesy National Museum of American Art, museum purchase made possible by Mrs. N.H. Green, Dr. R. Harlan, and Francis Musgrave.

Gerome Kamrowski (born 1914), *The Spectral Attitudes,* 1941, oil on canvas, 1986.92.62, © 1995 Smithsonian Institution, courtesy National Museum of American Art, gift of Patricia and Phillip Frost.

Franz Kline (1910–1962), *Blueberry Eyes,* 1959–1960, oil on paperboard, 1982.57, © 1995 Smithsonian Institution, courtesy National Museum of American Art, gift of the Woodward Foundation.

Claude Monet (1840–1926), *Red Boats, Argenteuil,* 1875, oil on canvas, courtesy of the Fogg Art Museum, Harvard University Art Museums, 1951.54, bequest of Collection of Maurice Wertheim, Class of 1906.

Rembrandt Harmensz van Rijn (Leiden, 1606–1669, Amsterdam), *Rembrandt Leaning on a Stone Sill,* 1639, etching on paper, courtesy of the Fogg Art Museum, Harvard University Art Museums, M12899, gift of Arnold Knapp.

Dante Gabriel Rossetti (1828-1882), *A Sea Spell,* 1875–1877, oil on canvas, courtesy of the Fogg Art Museum, Harvard University Art Museums, 1939.92, gift of Grenville L. Winthrop.

Edward Savage (1761–1817), *The Washington Family,* 1789–1796, oil on canvas, National Gallery of Art, Washington, D.C., Andrew W. Mellon Collection, 1940.1.2.

Henry Ossawa Tanner (1859 USA–1937 France), *Mountain Landscape, Highlands, NC,* 1889, watercolor, pencil, and colored pencil on paper mounted on paperboard, 1983.95.25, © 1995 Smithsonian Institution, courtesy National Museum of American Art, gift of Mr. and Mrs. Norman B. Robbins.

Henry Ossawa Tanner (1859 USA–1937 France), *Marshes in New Jersey,* 1895, pastel and pencil on paper mounted on paperboard, 1984.149.3, © 1995 Smithsonian Institution, courtesy National Museum of American Art, gift of Mr. and Mrs. Alfred T. Morris, Jr.

PAGE 4:

Photo by Daniel Grogan.

PAGE 8:

TOP LEFT: Doran H. Ross, *State Stool of the Queen Mother of Mampong,* Mampong, Ghana, 1976, Fowler Museum of Cultural History.
LEFT CENTER: Doran H. Ross, *Stool (dwa),* Ashanti Region, Ghana, 1976, Fowler Museum of Cultural History.
RIGHT CENTER: Doran H. Ross, *State Stool of Mampong,* Ashanti Region, Ghana, 1976, Fowler Museum of Cultural History.

BOTTOM LEFT: Doran H. Ross, *Paramount Chief of Cape Coast (Ogua) Riding in a Palanquin*, Cape Coast, Ghana, September 6, 1980, Fowler Museum of Cultural History.

PAGE 14:

Campus Photo Services, UMD.

PAGE 15:

LEFT: Eleise LaPorta, student exercise, 1995, the University of Maryland.

RIGHT: Albert Bierstadt (1830–1902), *Lake Lucerne*, 1858, oil on canvas, National Gallery of Art, Washington, D.C., 1990.50.1, gift of Richard M. Scaife and Margaret R. Battle, in honor of the 50th anniversary of the National Gallery of Art.

PAGE 16:

LEFT: Jelili Salako, manipulated image of Thomas Cole's *The Subsiding of the Waters of the Deluge* (student exercise), 1995, the University of Maryland.

RIGHT: Thomas Cole (1801 England–1848 USA), *The Subsiding of the Waters of the Deluge*, 1829, oil on canvas, 1983.40, © 1995 Smithsonian Institution, courtesy National Museum of American Art, gift of Mrs. Katie Dean in memory of Minnibel S. and James Wallace Dean.

Stated below is the NMAA's language regarding the use of manipulated images.

The MESL project gave NMAA staff an opportunity to see some of the ways that images were used by students, prompting a discussion among staff about image manipulation and its appropriateness. We feel that it is important to balance the needs of the universities against the responsibility that we have to the artists and artworks that form our collection. Accordingly, NMAA developed a policy that permits image manipulation for student assignments, but restricts subsequent publication of these manipulations.

Within the context of the MESL project, to ensure a full and fair reporting of the MESL experience from both the museum and university perspectives, we are permitting publication of manipulated images as a special one-time exception to this policy which is stated below.

NMAA Policy on Manipulation of Images

NMAA agrees with the terms of the MESL license that permit digital manipulation of museum artworks for educational, curricular purposes. As classroom assignments involving MESL images have demonstrated, manipulation of artworks can be a valid part of the learning experience that permits students to gain new insights about composition, aesthetics, and artistic intent.

NMAA further asserts that, although manipulation of artworks can serve valid educational purposes, subsequent publication by electronic or other means misrepresents an artist's original intent and the integrity of the artwork. NMAA therefore declines to give permission for publication of manipulated images. This policy applies to all artworks from NMAA regardless of whether the artwork is contemporary or from an earlier time period.

By applying this policy consistently, NMAA feels that it can best represent the artists whose artworks form part of our collections while still allowing use of our images in class assignments.

PAGE 17:

Emanuel Gottlieb Leutze (1816 Germany–1868 USA), *Westward the Course of Empire Takes Its Way* (mural study, U.S. Capitol), 1861, oil on canvas, 1931.6.1, © 1995 Smithsonian Institution, courtesy National Museum of American Art, bequest of Sara Carr Upton.

PAGE 18:

Albert Bierstadt (Solinger (near Dusseldorf), 1803–1902, New York, NY), *Rocky Mountains, Lander's Peak*, 1863, oil on linen, courtesy of the Fogg Art Museum, Harvard University Art Museums, 1895.698, bequest of Mrs. William Hayes Fogg.

PAGE 19:

FIGURE 6: Campus Photo Services, UMD.

FIGURE 7: Honoré-Victorin Daumier (Marseille, 1808–1879, Valmondois), *The Legislative Belly (Le Ventre Législatif)*, 1834, lithograph on paper, courtesy of the Fogg Art Museum, Harvard University Art Museums, M13711, The Program for Harvard College.

PAGE 24:

LEFT: John Quidor (1801–1881), *The Headless Horseman Pursuing Ichabod Crane*, 1858, oil on canvas, 1994.120, © 1996 Smithsonian Institution, courtesy National Museum of American Art. Museum purchase made possible in part by the Catherine Walden Myer Endowment, the Julia D. Strong Endowment, and the Director's Discretionary Fund.

RIGHT: John Quidor (1801–1881), *The Return of Rip Van Winkle*, ca. 1849, oil on canvas, National Gallery of Art, Washington, D.C., Andrew W. Mellon Collection, 1942.8.10.

PAGE 25:

Thomas Cole (1801 England–1848 USA), *The Pilgrim of the Cross at the End of His Journey (study for series, The Cross and the World)*, ca. 1846–1848, oil on canvas, 1965.10, © 1995 Smithsonian Institution, courtesy National Museum of American Art.

PAGE 40:

Edward Savage (1761–1817), *The Washington Family*, 1789–1796, oil on canvas, National Gallery of Art, Washington, D.C., Andrew W. Mellon Collection, 1940.1.2.

PAGE 42:

TOP ROW, LEFT TO RIGHT: Sir Henry Raeburn (1756–1823), *Miss Eleanor Urquhart*, ca. 1793, oil on canvas, National Gallery of Art, Washington, D.C., Andrew W. Mellon Collection, 1937.1.101. Sir Henry Raeburn (1756–1823), *John Tait and His Grandson*, ca. 1793, with addition ca. 1800, oil on canvas, National Gallery of Art, Washington, D.C., Andrew W. Mellon Collection, 1937.1.103. George Romney (1734–1802), *Miss Juliana Willoughby*, 1781–1783, oil on canvas, National Gallery of Art, Washington, D.C., Andrew W. Mellon Collection, 1937.1.104. George Romney (1734–1802), *Mrs. Davies Davenport*, 1782–1784, oil on canvas, National Gallery of Art, Washington, D.C., Andrew W. Mellon Collection, 1937.1.105. Sir Joshua Reynolds (1723–1792), *Lady Caroline Howard*, 1778, oil on canvas, National Gallery of Art, Washington, D.C., Andrew W. Mellon Collection, 1937.1.106.

MIDDLE ROW, LEFT TO RIGHT: John Hoppner (1758–1810), *The Frankland Sisters*, 1795, oil on canvas, National Gallery of Art, Washington, D.C., Andrew W. Mellon Collection, 1937.1.111. Andrea del Verrocchio (1435–1488), *Giuliano de' Medici*, ca. 1475/1478, terra cotta, National Gallery of Art, Washington, D.C., Andrew W. Mellon Collection, 1937.1.127. Ercole de' Roberti (1451/1456–1496), *Giovanni II Bentivoglio*, ca. 1480, tempera and oil on panel, National Gallery of Art, Washington, D.C., Samuel H. Kress Collection, 1939.1.219. Ercole de' Roberti (1451/1456–1496), *Ginevra Bentivoglio*, ca. 1480, tempera and oil on panel, National Gallery of Art, Washington, D.C., Samuel H. Kress Collection, 1939.1.220. Giorgione and Titian (1477/1478–1510, ca. 1490–1576), *Portrait of a Venetian Gentleman*, ca. 1510, oil on canvas, National Gallery of Art, Washington, D.C., Samuel H. Kress Collection, 1939.1.258.

BOTTOM ROW, LEFT TO RIGHT: Titian (ca. 1490–1576), *Portrait of a Lady*, ca. 1555, oil on canvas, National Gallery of Art, Washington, D.C., Samuel H. Kress Collection, 1939.1.292. Edward Savage (1761–1817), *The Washington Family*, 1789–1796, oil on canvas, National Gallery of Art, Washington, D.C., Andrew W. Mellon Collection, 1940.1.2. Gilbert Stuart (1755–1828), *Catherine Brass Yates (Mrs. Richard Yates)*, 1793/1794, oil on canvas, National Gallery of Art, Washington, D.C., Andrew W. Mellon Collection, 1940.1.4. Gilbert Stuart (1755–1828), *George Washington (Vaughan-Sinclair portrait)*, 1795, oil on canvas, National Gallery of Art, Andrew W. Mellon Collection, 1940.1.6. Gilbert Stuart (1755–1828), *John Randolph*, 1804/1805, oil on canvas, National Gallery of Art, Washington, D.C., Andrew W. Mellon Collection, 1940.1.9.

PAGE 43:

FIGURE 8: Edward Savage (1761–1817), *The Washington Family*, 1789–1796, oil on canvas, National Gallery of Art, Washington, D.C., Andrew W. Mellon Collection, 1940.1.2.

FIGURE 9: TOP ROW, LEFT TO RIGHT: Ralph Eleaser Whiteside Earl (1788–1838), *Family*

Portrait, 1804, oil on canvas, National Gallery of Art, Washington, D.C., 1953.5.8, gift of Edgar William and Bernice Chrysler Garbisch. Sir Thomas Lawrence (1769–1830), *Lady Mary Templetown and Her Eldest Son*, (1802), oil on canvas, National Gallery of Art, Washington, D.C., Andrew W. Mellon Collection, 1937.1.96. Susan C. Waters (1823–1900), *Brothers*, ca. 1845, oil on canvas, National Gallery of Art, Washington, D.C., 1956.13.8, gift of Edgar William and Bernice Chrysler Garbisch. American Eighteenth-Century, *The Cheney Family*, ca. 1795, oil on canvas, National Gallery of Art, Washington, D.C.,1958.9.9, gift of Edgar William and Bernice Chrysler Garbisch. American Nineteenth-Century, *The Proud Mother*, ca. 1810, oil on canvas, National Gallery of Art, Washington, D.C., 1971.83.18, gift of Edgar William and Bernice Chrysler Garbisch. Sturtevant J. Hamblin (active 1837/1856), *Sisters in Blue*, ca. 1840, oil on canvas, National Gallery of Art, Washington, D.C., 1978.80.19, gift of Edgar William and Bernice Chrysler Garbisch.

BOTTOM ROW, LEFT TO RIGHT: Edward Savage (1761–1817), *The Washington Family*, 1789–1796, oil on canvas, National Gallery of Art, Washington, D.C., Andrew W. Mellon Collection, 1940.1.2. Sir Joshua Reynolds (1723–1792), *Lady Elizabeth Delmé and Her Children*, 1777–1779, oil on canvas, National Gallery of Art, Washington, D.C., Andrew W. Mellon Collection, 1937.1.95. Gari Melchers (1860–1932), *The Sisters*, 1884/1900, oil on canvas, National Gallery of Art, Washington, D.C., 1957.4.2, gift of Curt H. Reisinger. American Nineteenth-Century, *The Sargent Family*, 1800, oil on canvas, National Gallery of Art, Washington, D.C., 1953.5.49, gift of Edgar William and Bernice Chrysler Garbisch. Milton W. Hopkins (1789–1844), *Aphia Salisbury Rich and Baby Edward,* ca. 1833, oil on wood, National Gallery of Art, Washington, D.C., 1971.58.9.12, gift of Edgar William and Bernice Chrysler Garbisch. American Nineteenth-Century, *Sisters in Black Aprons*, ca. 1835/1840, oil on canvas, National Gallery of Art, Washington, D.C., 1971.83.19, gift of Edgar William and Bernice Chrysler Garbisch.

PAGE 44:

LEFT: Sturtevant J. Hamblin (active 1837/1856), *Sisters in Blue*, ca. 1840, oil on canvas, National Gallery of Art, Washington, D.C., 1978.80.19, gift of Edgar William and Bernice Chrysler Garbisch.

RIGHT: American Nineteenth-Century, *Sisters in Black Aprons*, ca. 1835/1840, oil on canvas, National Gallery of Art, Washington, D.C., 1971.83.19, gift of Edgar William and Bernice Chrysler Garbisch.

PAGE 65:

John Singer Sargent (Florence, Italy, 1856–1925, London, England), *The Grand Canal, Venice*, ca. 1902, watercolor over graphite on white wove paper, courtesy of the Fogg Art Museum, Harvard University Art Museums, 1943.313, bequest of Grenville L. Winthrop.

PAGE 67:

Ben Shahn (Kovno (now Kaunas), Lithuania, 1898–1969, New York, NY), *Untitled (Houston Street Playground, New York City)*, ca. 1932–ca. 1936, gelatin silver print, courtesy of the Fogg Art Museum, Harvard University Art Museums, P1970.2478, gift of Bryson Shahn.